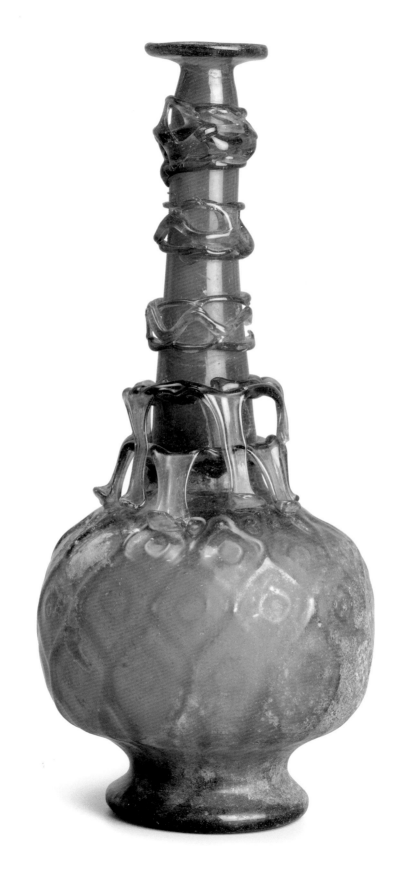

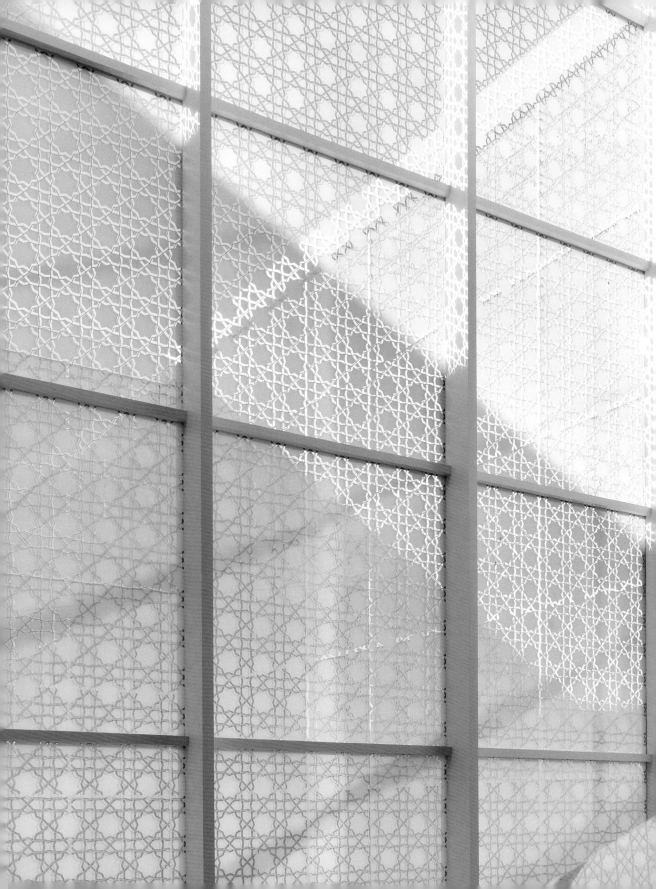

Aga Khan Museum Guide

AGA KHAN MUSEUM

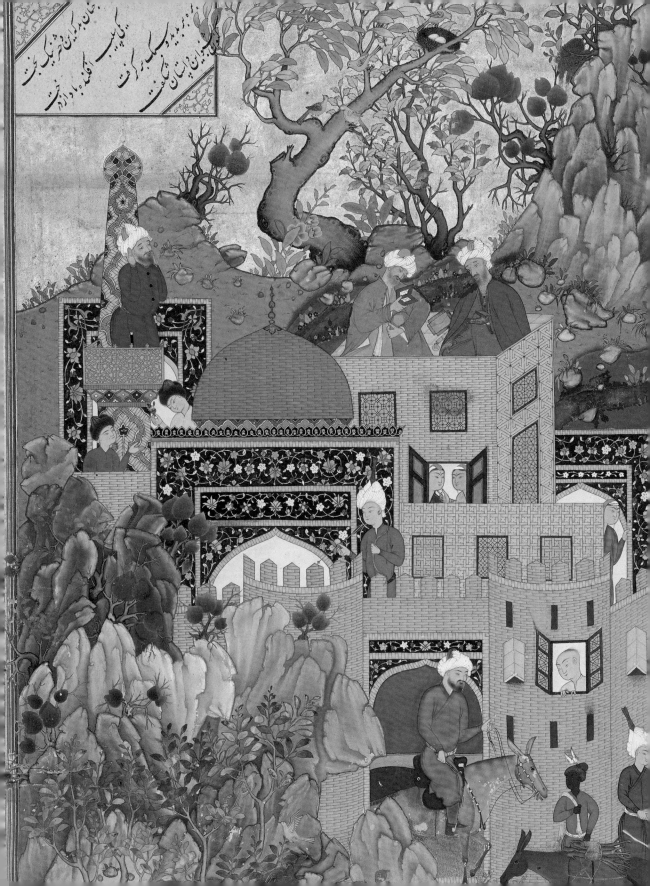

Contents

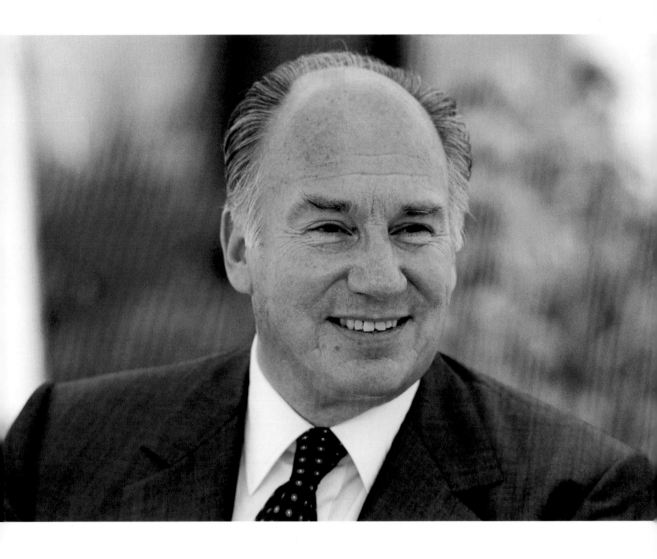

Foreword

His Highness the Aga Khan

The Aga Khan Museum in Toronto reflects my family's and my ongoing commitment to pluralism and to the promotion of understanding between civilizations, religions, and races.

Our plans in Toronto originally called for the construction of a new Ismaili Centre, a space of prayer, contemplation, study, and community interaction. As time went on, however, and added space became available, enlarging our original site, our plans grew to involve three separate yet interrelated developments: the Ismaili Centre Toronto, the sixth such representational building in the world; the Aga Khan Museum; and what we believe is a beautiful, welcoming park, open to the public, that links these two new buildings.

I think one can say that, together, these three projects symbolize the harmonious integration of the spiritual, the artistic, and the natural worlds—in keeping with the holistic ideal and approach that is such an intimate part of Islamic tradition. At the same time they also express our profound commitment to intercultural engagement and to international co-operation. The creative process behind this development has itself been a remarkable international story—it brings together designs of architects from Japan, India, and Lebanon, working with the Toronto firm of Moriyama & Teshima, and adapting age-old architectural traditions in a contemporary Canadian idiom.

The story of this site is connected to Canada's historic welcome to displaced Ismailis in the 1970s and later, and to their successful integration into Canadian life and society. Certainly, this process and the contributions Ismailis have made in so many walks of life reflect the encouragement they received here to rebuild their traditional institutions and social structures in this country. In looking back over these recent decades, I remember, with deep gratitude, the close collaboration the Aga Khan Development Network has enjoyed with institutions such as the Canadian International Development Agency, which has been and today as part of Foreign Affairs, Trade and Development Canada continues

to be a key partner in addressing the needs of the developing world. So, too, we appreciate the strong relationships our educational institutions have enjoyed these many years with great Canadian centres of learning such as McMaster and McGill Universities, the University of Toronto, and the University of Alberta. And we are proud of our partnering with the Canadian government in the development of the Global Centre for Pluralism, based in Ottawa, which expresses our shared conviction that the progress of civilization depends on our ability to understand, embrace, and energize the power of human diversity. It is from this strong base of co-operative endeavour covering many years that these projects on Wynford Drive have emerged. They have been inspired, too, by Toronto's own success as a vibrant cultural centre.

The Museum's focus on the arts of Islam makes it something of a unique institution in North America, which will contribute we hope to a better understanding of Muslim civilizations — and especially of both the plurality within Islam itself and of Islam's relationship to other traditions. It is a place for sharing a story, through art and artifacts, of highly diverse achievements going back more than fourteen hundred years, honouring the central place within Muslim civilizations of the search for knowledge and beauty. And it illuminates both the inspiration that Muslim artists have drawn from their faith, as from the wide and varied array of epics, of stories that recount or reflect the human condition with the universal themes of love and loss, of joy and despair, common to all civilizations at all times. In a world in which some speak of a growing clash of civilizations, we hope and believe that the Museum will help to address what is not so much a clash of civilizations as it is a clash of ignorance. The new Museum has a strong educational vocation: it is a place for active inquiry, for discussion and research, for lectures and seminars, and for an array of collaborative programs with educational institutions, scholars, thinkers, and other museums.

My own family has been intimately involved in Islamic cultural history, notably during the Fatimid Caliphate, which a thousand years ago founded one of the world's first great universities in Cairo. The core collection of the new Museum in Toronto includes elements that have been gathered by my family through many generations, including the miniatures collected by my uncle, the late Prince Sadruddin Aga Khan, displayed in a replica of the Bellerive Room from my late uncle's home in Geneva. We are deeply grateful to Princess Catherine, his widow, for this generous gift.

The Toronto Museum belongs to the institutional framework of the Aga Khan Trust for Culture, already the sponsor of projects for restoring and preserving cultural heritage in places such as Syria, India, Pakistan, Mali, and parts of Central Asia, including Afghanistan, and which has created or promoted museums in Egypt, Zanzibar, and

Chantilly in France. The Aga Khan Trust for Culture is active, too, in educational programs, for instance, with Harvard University and the Massachusetts Institute of Technology, and is well-known for its Aga Khan Award for Architecture, an important honour in that discipline.

All in all, the Wynford Drive complex represents a rich tapestry woven from varied strands. And the fact that we have come so far in pursuit of this dream owes everything to those who have believed in it so deeply. We are grateful for the support of so many public officials, successive Canadian prime ministers, regional and city leaders, and local ward councillors. We also salute the contractors, as well as our museum partners from around the world, the members of the Bata family whose support has been so helpful, and the staff and volunteers who have given so much of themselves to this effort. We owe a great deal to all who have made gifts of time and treasure and of endeavour to this project, including, most especially, the Ismaili community in Canada and around the world who have contributed to the development of Ismaili Centres and Jamatkhanas, and to the fund that was set up to commemorate my Golden Jubilee. This project has been designated as a Golden Jubilee project and is a beneficiary of those generous gifts.

I should also say that we hope that the Museum building itself will be recognized as an important work of art, of architecture, designed by the renowned Japanese architect Fumihiko Maki. His beautiful building in Ottawa has already been the home for the Delegation of the Ismaili Imamat since 2008. That building was inspired by the evanescent mysteries of rock crystal. This new Museum here in Toronto takes as its theme the concept of light—suffusing the building from a central courtyard with patterned glass walls and from high lantern windows in the roof. From the outside, this building glows by day and by night, lit by the sun and the moon. The Divine Light of the Creator is reflected in the glow of individual human inspiration. As the thirteenth-century poet Rumi has written, "The light that lights the eye is also the light of the heart . . . but the light that lights the heart is the Light of God."

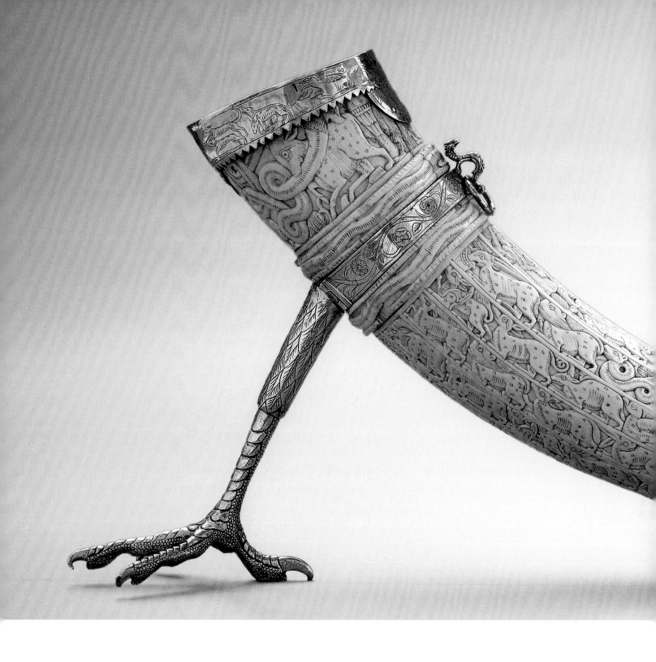

A Journey Across Cultures and Time: The Aga Khan Museum's Vision

Henry S. Kim

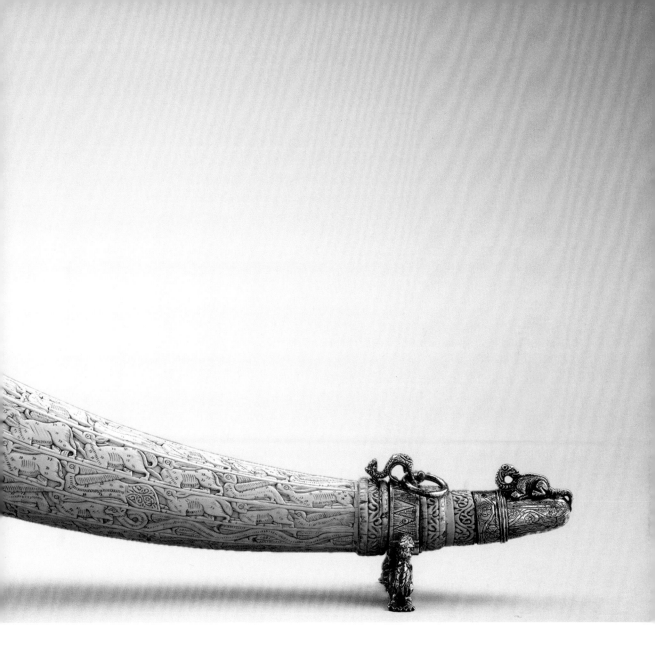

Ivory Horn (Oliphant),
southern Italy,
11th–12th centuries
(mount: Great Britain,
early 17th century),
carved ivory with
silver mount, length
64 cm, height 34 cm,
AKM809.

For visitors who come to the Aga Khan Museum, the objects they encounter can be seen as points in a journey that connect cultures across time. The history of Islamic civilizations is one that can be characterized by continuous encounters with neighbouring peoples over fourteen hundred years. Spread across a vast region that stretched from Spain in the west to China in the east, the opportunities for interactions abounded, fuelled by trading contacts made over the land-based Silk Road and the maritime routes of the spice trade, and through cohabitation in regions such as Spain, Sicily, Africa, the Balkans, Central Asia, China, India, and Southeast Asia.

These encounters left their indelible mark on the arts from the region, something that the Aga Khan Museum is keen to demonstrate in its displays, exhibitions, and performing arts. Included in this essay are some of the more important examples that can be seen in the art from the Museum's collection. Some show remarkable similarities to techniques of decoration and manufacture from the Chinese world. Others reflect styles, forms, and knowledge from the ancient world of Greece and Rome, while certain ones are borrowed directly from Western traditions and some are made by artists from outside the Muslim world. In all cases they show the importance of external influences in the development of the art of Islamic civilizations and reflect the vibrant culture of encounters that took place historically.

A remarkable instance of cross-cultural fertilization over time and regions can be seen in the ivory oliphant or hunting horn in the Museum's collection (AKM809, see also page 117). The first recorded use of the word *oliphant* occurs in the twelfth-century French epic poem *La Chanson de Roland* where the titular hero, before he dies, sounds an oliphant to warn Charlemagne's army against a Muslim attack during the late-eighth-century Battle of Roncesvalles.

Oliphants were likely known in Egypt during the Fatimid dynasty (909–1171), though none have been preserved and they are not found in depictions of hunters in Iranian art. Scholars believe numerous examples were produced in Sicily and southern Italy by Muslim craftsmen after the Normans took complete control of Sicily from the Arab Kahbid dynasty, vassals of the Fatimids, at the end of the eleventh century. The Museum's hunting horn, like other oliphants with iconography such as repetitive real and imaginary animals derived from Islamic traditions, were highly prized by Christian European nobility and often found their way into monasteries and churches. Silver mounts were added to the Museum's oliphant in Britain in the early seventeenth century, possibly indicating some new ceremonial function and demonstrating further how a device that had already derived much from a confluence of Islamic and European cultures could be repurposed yet again.

In a similar fashion, a tenth-century capital in the Museum's collection (AKM663) from Spain reminds one of the Corinthian capitals found in Roman and Visigothic ruins all over the Iberian Peninsula. The basic structure of Corinthian capitals is maintained here, but the two rows of deeply carved acanthus leaves are rendered sprightlier and with more verve. This capital possibly topped a column in one of the many palaces erected in the Spain of the Umayyads (756–1031) only to be reused by Christians elsewhere later.

The *Qanun [fi'l-tibb]* or Canon [of Medicine] by the Iranian scholar Ibn Sina (known as Avicenna in the West) was written within fifteen years of the polymath's death in

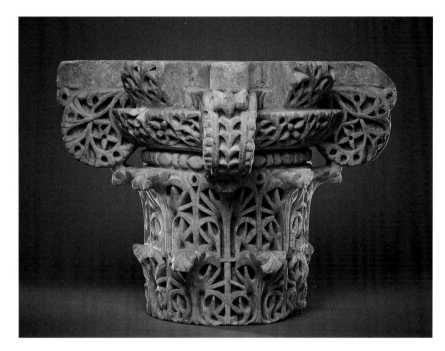

1037. The *Qanun*'s five volumes are a compendium of Greco-Roman medical learning featuring the wisdom of Aristotle and Galen wedded with the Chinese knowledge of Ibn Sina's time. The folio illustrated here is from the *Qanun*'s fifth volume (AKM510, see also page 74), one of two volumes in the Museum's collection (the other is the fourth) and possibly one of the earliest if not the earliest extant manuscript of this work.

Volume 5 tells of compound drugs and pharmacopoeia, while the other volumes cover topics such as anatomy, the humours, general and specific pathology, diseases, fractures, and surgery. The *Qanun* serves as a tangible bridge between the Classical world, Islam, and Europe, especially since Ibn Sina's great work was translated into Latin in the thirteenth century and eventually into other European languages and became an essential medical text in Western medical colleges well into the eighteenth century. Even today it has an important place in Indian Unani, an alternative form of medical practice related to Ayurvedic medicine.

A scientific instrument that is extraordinary not only visually and technically but also for what it can tell us about the time when it was made is the Museum's Spanish astrolabe (AKM611, see also page 78). It is a magnificent object of craftsmanship and science that transforms practical information into an object of

beauty. As an object, it represents the advancement of science in the Muslim world and how this knowledge was passed on to other cultures that encountered it.

An astrolabe is a navigational and timekeeping instrument whose name comes from the Greek for "star-taker." The practice of using stars to navigate and keep time can be traced to the ancient world where Greek astronomers developed an advanced knowledge of the stars and their progression across the sky through a year. Instruments that helped astronomers predict the location of stars relative to the ground are believed to have existed as early as the second century BCE and were used into Byzantine times. What makes the Museum's fourteenth-century astrolabe exceptional are the inscriptions found on it. Most astrolabes have inscriptions in one language, but the Museum's piece has three — Latin, Arabic, and Hebrew. The inscriptions help place where the object was made. It comes from Spain where the cultures of Christianity, Islam, and Judaism met and where Islam had a firm European foothold. The Latin and Arabic inscriptions were written at the time when the astrolabe was originally manufactured, supporting the idea that it was made for communities where Arabic and Latin were both used. Hebrew

Planispheric Astrolabe, Spain (Historic al-Andalus), 14th century, bronze inlaid with silver, diameter 13.5 cm, AKM611.

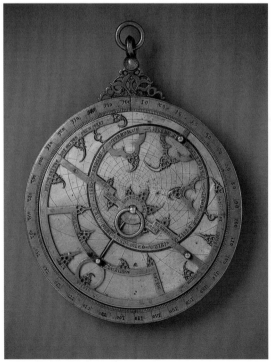 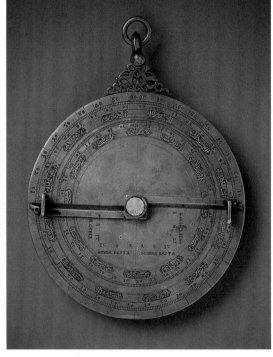

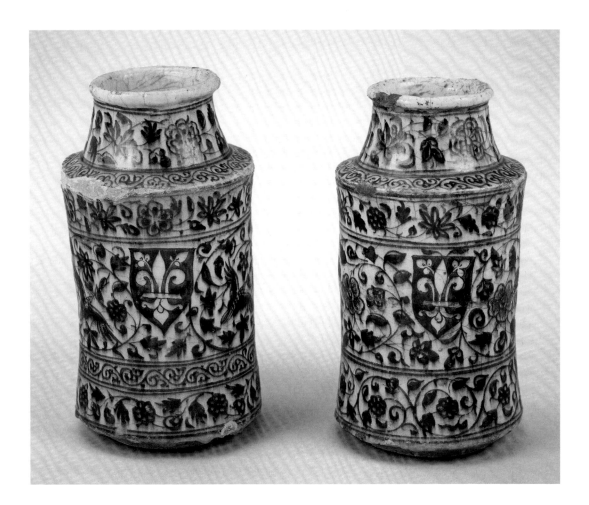

Pharmacy Jars
(*Albarelli*), Syria,
15th century, fritware,
underglaze-painted.
AKM567: diameter
49.4 cm, height 32 cm.
AKM568: diameter
49.4 cm, height 30.7 cm.

seems to be a later addition, appearing as light scratches on one of the "maps," suggesting reuse by a Jewish astronomer or navigator.

For millennia the trading of goods has been the engine of cross-cultural exchange. Two fifteenth-century Syrian pharmacy jars or *albarelli* in the Museum's collection (AKM567 and AKM568, see also page 67) are prime examples of how this dynamic worked. *Albarelli* were traded during the Mamluk era (1250–1517) between the Middle East and Italian city-states for their artistic value or as containers of precious pharmaceutical substances. Many French, Spanish, and Italian inventories from the fourteenth and fifteenth centuries record ceramic objects "from Damascus," and more specifically the Medici archives list the presence of *albaregli damaschini* in Florence.

The central, wider band of each of these *albarelli* features a fleur-de-lys heraldic shield that could be the crest of Florentine merchants who commissioned the goods once contained in the jars or it may signify the city the important trade was based in. Italian merchants were often found in Cairo, Damascus, and Beirut in the fifteenth century and it is possible one of them ordered these jars for a Florentine apothecary or perhaps

even for medical use in his own home. However, the fleur-de-lys was also used by several Mamluk sultans and emirs until the fifteenth century and has been noted on certain monuments in Syria.

More than a dozen painters, at least two calligraphers, several miniaturists, bookbinders, polishers, gold stipplers, and margin creators, along with a sizable platoon of assistants from various Iranian and Central Asian regions pooled their talents at the behest of the Safavid Shah Tahmasp I (1524–76) to create a *Shah-Nameh* (see also pages 96, 98–100, 102–05, and 113) that became arguably the most remarkable Iranian manuscript ever produced. The *Shah-Nameh*, Iran's national epic poem, was written by Ferdowsi in the late tenth and early eleventh centuries and recounts the mythical and historical past of Iran from the creation of the world until the Muslim conquest of Persia.

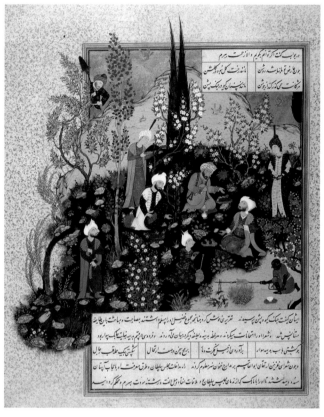

Ferdowsi Encounters the Court Poets of Ghazni, folio from a *Shah-Nameh* (Book of Kings) produced for Shah Tahmasp I, Tabriz, Iran, ca. 1532, opaque watercolour, ink, and gold on paper, 45 × 30 cm, AKM156.

Ten folios from this extraordinary manuscript are part of the Aga Khan Museum's collection. The folio illustrated here (AKM156) is entitled *Ferdowsi Encounters the Court Poets of Ghazni* and was likely completed circa 1532. Ferdowsi (at the extreme left of the illustration) departed from his native Tus in northeast Iran and journeyed to Ghazni in present-day Afghanistan to seek the patronage of Sultan Mahmud. Before he could meet with the sultan, though, he was confronted by three court poets (the central grouping in the illustration) who challenged his abilities as a poet but eventually recognized his superior talent.

Combining lore and history, the *Shah-Nameh* provides models of conduct that inspired numerous generations of rulers. The poem, in fact, can be considered a "mirror for princes," a popular genre in the medieval and early modern Islamic world that sought to show how rulers should behave. Various neighbouring peoples such as Georgians, Armenians, Kurds, and Pashtuns mined the *Shah-Nameh* for their own storytelling, and

Western writers in later periods such as the German author Goethe also found much to admire in Ferdowsi's remarkable achievement and Persian literature in general. Goethe even penned a book of poems — *West-Eastern Divan* — that was inspired by the Iranian poet Hafez.

Iznik is the name the Ottomans (1299–1923) gave to the Byzantine city of Nicaea after they conquered it in 1331. The manufacturing of ceramics had been a focus for Iznik even in later Byzantine times, but it was in the fifteenth century that the city truly came into its own as a celebrated centre of ceramic production. These two tiles in the Aga Khan Museum's collection (AKM583 and AKM584, see also page 67) possibly once adorned an Ottoman mosque or palace.

The Ottoman sultans greatly admired Chinese blue-and-white porcelain. Their own potters were unable to reproduce porcelain because of the lack of kaolin as raw material, but they were able to create fritware, ceramics composed largely of silica and glass. Seeming imitation of Chinese originals soon gave way to inventive adaptation so that by the mid-sixteenth century, Iznik had developed its own repertoire of tightly organized floral and abstract motifs as seen in the Museum's tiles. However, as the century progressed, various colours such as red (already seen on AKM583 and AKM584) and green became more common and patterns got more elaborate and even quirky.

A sort of reverse dynamic is represented by a porcelain dish (AKM591) manufactured in seventeenth-century Zhangzhou, China. The Museum's dish is an example of a ware

Tiles, Iznik, Turkey, ca. 1560, fritware, underglaze-painted, each 25 × 24.5 cm, AKM583 and AKM584.

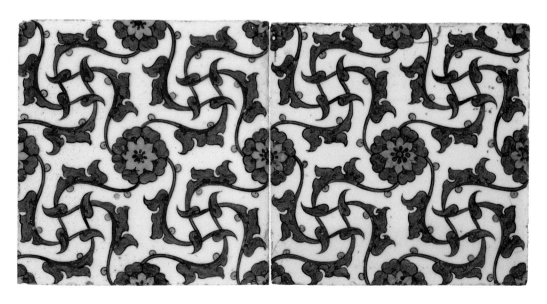

called Swatow, a Dutch mistranslation of Shantou, the port from which such ceramics were supposedly shipped during the Qing dynasty (1644–1912). These dishes were exported to Europe, Japan, and Southeast Asia between the mid-sixteenth and mid-seventeenth centuries, and similar ones appeared in Indonesia and are thought to have been commissioned by the powerful seventeenth-century Shia sultans of Aceh in northwest Sumatra.

The inscriptions on AKM591 feature verses from the Qur'an, including Surat al-Baqara ("The Cow"), Surat al-Ikhlas ("Fidelity"), and Surat al-Nas ("The People"), as well as invocations to Allah. Such inscriptions were meant as protection and assistance for the owner.

Dish, Zhangzhou, China, 17th century, porcelain, underglaze-painted, diameter 35.1 cm, AKM591.

A Resting Lion, single-page drawing, attributed to Mo'in Mosavvir, Isfahan, Iran, 1672, ink, opaque watercolour, and gold on paper, image 6.2 × 12 cm, folio 14.1 × 22.5 cm, AKM111.

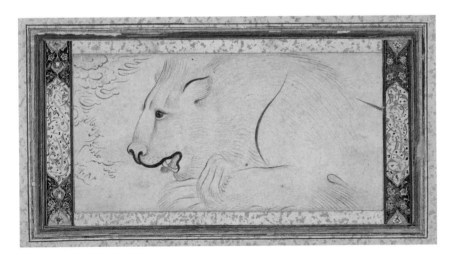

One of the foremost Iranian artists was Mo'in Mosavvir (died 1697), who frequently signed his own works and dated them. The main subject and the treatment of clouds in *A Resting Lion* (AKM111, see also page 112), attributed to Mosavvir, exhibit Chinese influence, but the artist has made the drawing his own through his self-assured brush-strokes and playful portrayal of the king of beasts. Although the lion may be "at rest" with his right paw crossed over his left, his open mouth displays a red tongue and deadly fangs.

Mosavvir would have been all too familiar with the danger of wild animals since he showed a tiger mauling a boy in another drawing now in the Museum of Fine Arts in Boston. Apparently, the artist heard about the attack and made the drawing a week later. Resting indeed!

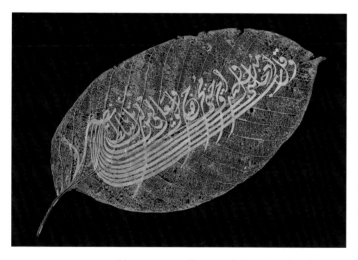

Leaf with Calligraphic Composition, Turkey, 19th century, gold on chestnut leaf, 13.5 × 28 cm, AKM538.

Qur'anic inscriptions are found on all manner of objects, including a mother-of-pearl shell (AKM665, see page 121) and wooden beams (AKM701 and AKM628, see pages 140–43), but one of the most extraordinary media boasting a passage from the Qur'an is without doubt a gilded sweet chestnut leaf (AKM538, see also page 123). The leaf features a verse from Surat al-Isra ("The Night Journey"): "And say, 'Lord, grant me a good entrance and a goodly exit, and sustain me with your power.'" Masterfully, using the characters of the verse, the calligrapher creates a boat filled with people, oars dipping into "water" and perhaps conjuring the journey we all take, a connection all cultures and their peoples should find relevant.

Ten objects, ten illustrations of the cross-cultural nature of the arts of Islamic civilizations. For the Aga Khan Museum, these objects are as important for their inherent beauty as for the wealth of knowledge that comes from viewing and understanding them. The Museum through its public programs will place special emphasis on the culture of encounters that occurred historically to shape the arts of the region. Its goal is to present the arts of Islamic civilizations not in isolation but as an integral part of an artistic and cultural ecosystem that connects East to West from the seventh century to the present day.

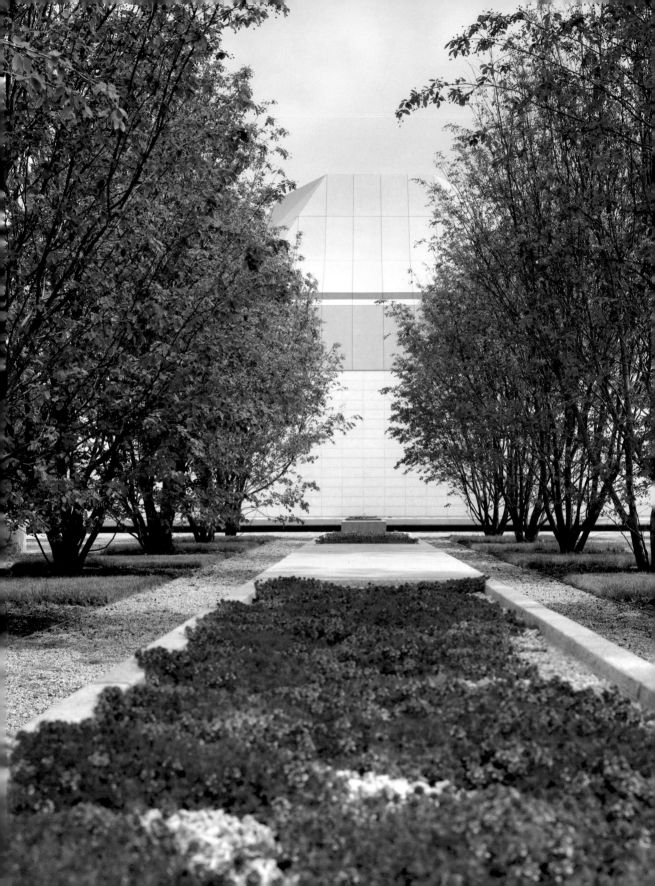

A Conversation with Fumihiko Maki, Architect of the Aga Khan Museum

Philip Jodidio

When His Highness the Aga Khan decided that the noted Japanese architect Fumihiko Maki would design a new museum in Toronto,[1] he wrote him a long letter. In that letter he stated: "For the Aga Khan Museum, I thought that 'light' might be a concept around which you could design an outstanding museum. The notion of light has transversed nearly all of human history, and has been an inspiration for numerous faiths, going as far back of course to the Zoroastrians and their reverence for the Sun, to the *Sura* in the Holy Qur'an titled *al-Nur*.[2] Decades of Western history are referred to as the 'enlightenment' for good reason."[3] In a sense, the entire effort of His Highness the Aga Khan, beginning with his ongoing dedication to the Ismaili community and continuing with such initiatives as the Aga Khan Award for Architecture or the Aga Khan Program for Islamic Architecture at Harvard University and the Massachusetts Institute of Technology, has led to this: a museum dedicated not only to the display of exceptional objects of Islamic art but also to music, to education — and to a sense of pluralism and openness that he found in Canada but that he first and foremost finds in Islam.

An Outstanding Architect

Born in Tokyo in 1928, Fumihiko Maki received his bachelor's degree in architecture from the University of Tokyo (1952) and went on to obtain master's degrees from both the Cranbrook Academy of Art (1953) and the Harvard Graduate School of Design (1954). He worked for Skidmore, Owings & Merrill in New York (1954–55) and Sert, Jackson and Associates in Cambridge, Massachusetts (1955–58), before creating his own firm, Maki and Associates, in Tokyo in 1965. Maki's study and early work in the United States undoubtedly influenced his extensive list of completed projects. His recent buildings include the Shimane Museum of Ancient Izumo (Izumo, Japan, 2006),

A summer view of the Aga Khan Museum building through trees in the Aga Khan Park.

21

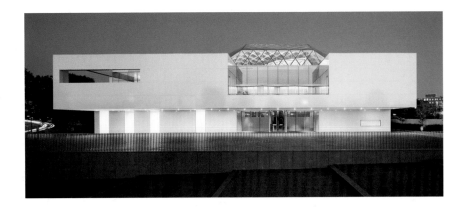

a structure similar in size to the Aga Khan Museum that uses a combination of glass and Corten steel, and World Trade Center Tower 4 (New York City), a sleek sixty-one-storey skyscraper completed in 2013. He is also the author of the Delegation of the Ismaili Imamat in Ottawa, Canada (2006–08).

Maki's status in the world of architecture is underlined by the fact that he has been granted three of the most prestigious awards of his profession: the Pritzker Prize (1993), the Praemium Imperiale (1999), and the AIA Gold Medal (2011). The Pritzker Prize Jury Citation offers an explanation of qualities that His Highness the Aga Khan has identi-

fied in Maki's work. It reads in part: "He uses light in a masterful way making it as tangible a part of every design as are the walls and roof. In each building, he searches for a way to make transparency, translucency and opacity exist in total harmony."[4]

As Maki explains, his good working relations with His Highness the Aga Khan have developed over time and

have been related to the interests of the Aga Khan in modern architecture. "In 1986," recalls Maki, "I was asked to be a member of the Master Jury of the Aga Khan Award for Architecture. At that time the Aga Khan was living near Geneva where we spent a few days selecting candidates for the award. I was invited again in 1992 to participate in the jury, a rare honour! I did not have much contact with His Highness again until the late 1990s when I got a call from a man who asked me if I would be interested in designing a new Ismaili Centre in Canada. Of course, I said yes. I met quite a few times with His Highness at Aiglemont near Chantilly [in France] during the design process. Sometimes, after the construction started, he asked us to be on-site for the selection of exterior stones. The Delegation of the Ismaili Imamat was well received. It was awarded a 2012 Governor General's Medal in Architecture as an example of the architecture of 'peace and plurality.'"[5]

Fumihiko Maki's Delegation of the Ismaili Imamat in Ottawa, Canada's capital, was awarded a 2012 Governor General's Medal in Architecture as an example of the architecture of "peace and plurality."

His Highness the Aga Khan (left) converses with Maki at the Aga Khan Museum exhibition at the Louvre in Paris in 2007.

How the Museum Was Conceived

Maki explains that the process for the design of the Aga Khan Museum was similar to that of the Delegation of the Ismaili Imamat. He was contacted about work on a new site in Toronto in 2004 before the completion of the Delegation building in Ottawa and was told the construction schedule would be rapid. As Maki says, "There was a meeting with the people from Geneva and Toronto and in particular Luis Monreal, the

General Manager of the Aga Khan Trust for Culture. We also visited the site and were given the program, which was quite precise in terms of size and functions. On the way back to Tokyo, I laid out my first thoughts and sketches, which are not far from my final project. This was in August 2004. We made some basic models shortly thereafter in Tokyo. Having prepared a basic concept, we presented it to His Highness at Aiglemont. He approved the scheme subsequent to our meeting."

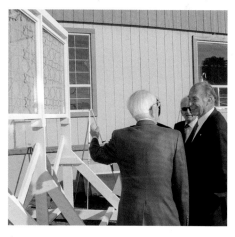

The architect emphasizes the fact that the completed building is very similar to his initial scheme. "The courtyard has changed in size since then," he says, "but the basic building is much as I originally imagined. I designed the facades to be receptive to natural light according to the time of day and the season. What is interesting about the placement is that north for this project is a diagonal, so every facade has some natural light depending on the time and the season. The same is true of the central court. We made presentations on several occasions during the design process. His Highness was interested in questions such as the textures, the colour of the stone, and also the way the light would fall. We were very fortunate that we encountered no major disapproval from His Highness."

As Maki describes the building, "Contained within a simple rectilinear footprint, the primary functions of the Museum revolve around a central courtyard, which acts as the heart of the building and integrates the different uses into a cohesive whole while allowing each space to maintain its independence, privacy, and character."[6] Eighty-one metres long by fifty-four metres wide, the building, as Maki says, is "compact," a fact related as much to the site and its future development as it is to the need to create a cohesive whole.

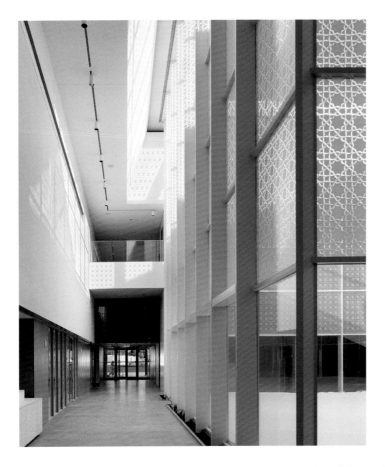

"We were asked to create a museum of a certain size," explains Maki, "but we decided to make it fairly compact because the possibility of future expansion was part of the program we were given, though no precise size was determined. The placement of Charles Correa's Ismaili Centre and the need to create green barriers around the site to protect it from traffic noise made the precise orientation and location of the Museum fairly evident. Aside from the exhibition of art, His Highness wished to hold events such as concerts in the Museum, and there is also sizable space for educating children about Islamic art. A shop and restaurant that can be used even by those not entering the Museum are provided for. This is not just a museum. It is actually more a cultural centre. We felt that a compact form would allow for the required functions and good communication between them."[7]

Each Design Is Unique

The completed Aga Khan Museum in Toronto presents relatively closed facades as seen from some exterior angles. "A museum," Maki says, "usually looks closed from the outside because you need wall space to hang and exhibit objects. Except for the entrance

The Aga Khan Museum's courtyard (on the right) serves, as Maki says, "as the heart of the building and integrates the different uses into a cohesive whole while allowing each space to maintain its independence, privacy, and character."

and public areas, most of the museum must be relatively closed. Of course, if you have extra passageways outside the exhibition space, you can do that, but that would increase the size. In the Aga Khan Museum the courtyard does bring in a good deal of natural light."

Asked if any specific work of his own or perhaps of other architects influenced his design in Toronto, the architect responds: "Each design is unique in terms of program, site, climate, and the client. I have designed many museums, but each one is very different. I have not been very much influenced by the museums designed by other architects, either. I appreciate many buildings like the Kimbell Museum in Fort Worth (Louis Kahn, 1972), but each architect is different." As for his reaction to the climate of Toronto, the architect states: "I have already designed other buildings in cold regions, so that aspect was not new for me. We had to be careful about frost and snow accumulation. For instance, in the interior courtyard we can't allow snow to pile up, so we have installed a heating system there. But Toronto is not like Maine or Quebec. It is relatively mild there compared to more extreme climates. Noise from the nearby highway is also a factor that required control. This is another reason that the building might appear to be relatively closed. Inside it is very quiet."[8]

The Aga Khan Museum is located on a 6.8-hectare site on Wynford Drive in the northwest quadrant of the Don Valley Parkway and Eglinton Avenue in Toronto. Aside from the Museum building by Maki, there is also the Ismaili Centre designed by the Indian architect Charles Correa and a park laid out by the Beirut-based landscape architect Vladimir Djurovic.

An artist's rendering of the Aga Khan Museum set within the Aga Khan Park.

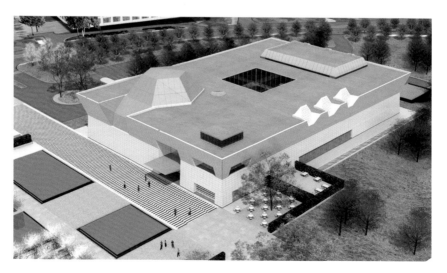

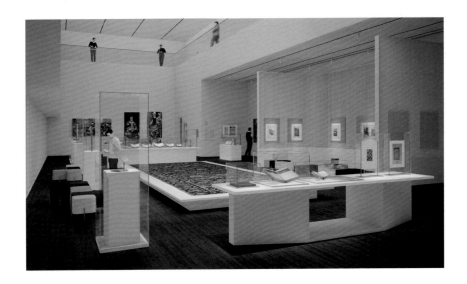

Maki explains: "Charles Correa won the competition for the Ismaili Centre in 1998. I was invited to participate as well, but I did not respond at that time. When we did come to be involved in the Museum, Charles Correa's design had already progressed considerably. It was thus a given element for our project. Vladimir Djurovic was invited to participate at the same time as I was. I would not say that my design reacts to that of Correa, but we tried to be very careful about issues such as height. In the Ismaili Centre there is a prayer hall that faces the direction of Mecca. We were asked to make the protrusion of the auditorium of the Museum lower than the dome of the Ismaili Centre, of course. The dome is also on the axis of the entrance to the Museum. I had more discussions with Djurovic than with Correa, since his design evolved at the same time as mine."[9]

Light in All Its Forms

The Aga Khan's letter sent to Maki at the outset of the Museum project, expressed with reference to the ephemeral but essential qualities of light, sets the tone for the architecture.[10] Quite obviously, Maki has taken these references to heart both in purely symbolic terms and in practical ones. The architect has been careful to create ideal conditions for the viewing of Islamic art, providing very low luminosity where delicate works might be shown, for example. Skylight screens with geometric patterns "inspired by the windows in mosques" and translucent walls are features of the exhibition spaces. The design is centred around a courtyard, intended as "a symbolic space, protected from the outside world," with an "inherent link to traditional Islamic architecture." The exterior of the Museum is "inspired by the forms and shapes of precious stones" and has walls inclined at two distinct angles to accentuate the play of light on the surfaces. White Brazilian granite was chosen as the main cladding material because of its good resistance to the

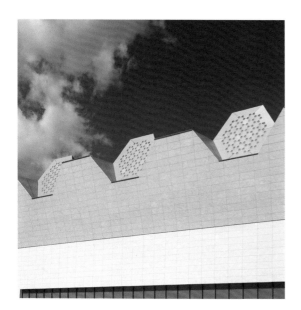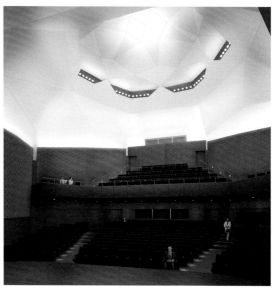

The angled skylights introduced into the Aga Khan Museum design by Maki are, of course, abstract, but they were inspired by the very subtle windows of the seventeenth-century Sheykh Lotfollah Mosque in Isfahan, Iran.

ABOVE RIGHT: The Aga Khan Museum's auditorium, according to Maki, "recalls the domes of Islam — perhaps the Bazaar in Kashan, Iran, for example. . . . His Highness wanted a modern building, but once you are inside, there should be a feeling of Islamic architecture. Some of the patterns or screens employed intentionally evoke this spirit."

climate. As for the relationship with Correa's Ismaili Centre, Maki states: "The metallic roof of the auditorium space further accentuates the shape and materiality of a precious stone and is intended to establish a formal dialogue with the crystal roof of Correa's Ismaili Centre. The primary entrance and axis of the Museum is aligned with the Ismaili Centre, which provides a subtle relationship between the two buildings, emphasizing the unity of the complex."[11]

Although he wishes for such references to remain discreet, Maki does reveal some of the sources of his thought where light is concerned. "The angular facade is able to refract natural light in quite an interesting way. The cladding of the building, in white granite, assumes different colours according to light conditions." More specifically, Maki says: "At sunset the Taj Mahal glows red or pink, while it appears to be white at noon." The architect goes on to refer to the interior of the Museum, stating: "There is some natural light, but we tried to design the openings very carefully, since much of the material exhibited is sensitive to light. I feel that references to Islamic architecture should be abstract in this instance, and the screens we have developed respond to this approach. The choice of cladding materials allows for a certain translucency from the inside, perhaps a bit like the effect created by the marble used in the Beinecke Rare Book Library at Yale designed by Gordon Bunshaft."[12]

In explaining the interior forms of the Museum's auditorium, Maki makes reference to a specific dome: "The auditorium recalls the domes of Islam — perhaps the Bazaar in Kashan, Iran, for example." The angled skylights introduced into the Museum design by the architect are, of course, abstract, but his own documentation refers to the very subtle windows of the Sheykh Lotfollah Mosque (Isfahan, Iran, 1603–19). On the whole, the architect has sought to carry out the wishes of the client. "In Ottawa and also here,"

he says, "His Highness wanted a modern building, but once you are inside, there should be a feeling of Islamic architecture. Some of the patterns or screens employed intentionally evoke this spirit."[13]

The Processes of Change

The dedication of the Aga Khan to architecture, seen in such ongoing programs as the Aga Khan Award for Architecture in which Maki was an active participant, has to do more with improving the conditions of life of a vast part of humanity than it does with heralding a new architectural style. Pointedly, the Aga Khan refers to architecture as part of "the processes of change"—a terminology that may be at odds with most descriptions of contemporary buildings. When asked if, for him, building is not, in fact, a way of bringing people together, he responds: "Yes, or giving them a sense of individuality. Sometimes they need that also. I think spirituality is not necessarily experienced only in a societal context. It can be very much an individual thing. In the Islamic world we always look at the fundamental unity of *din* and *dunya*, of spirit and life, and we cannot tolerate that one functions without the other."[14]

It is surely in the evocation of light in the Aga Khan Museum that the talent of Fumihiko Maki is felt, and the connection between the client and the architect is most readily apparent. It is no accident that in describing "light" in his original letter to Maki, the Aga Khan passes directly from an evocation of a sura of the Qur'an to a reference to the European Enlightenment. The light he refers to crosses through civilizations and religions—it is the source of life and art, the two forces being brought together in the walls of the Aga Khan Museum. The ultimate message of pluralism and tolerance conveyed by His Highness the Aga Khan might best be summed up in this instance by his own references to the two sources of light, "natural light emanating from God's creation," and "light . . . which emanates from human sources, in the form of art, culture and well-inspired human knowledge."[15]

"The angular facade," Maki says of the Museum, "is able to refract natural light in quite an interesting way. The cladding of the building, in white granite, assumes different colours according to light conditions."

Notes

1. Design Architects: Fumihiko Maki and Maki and Associates, Tokyo, Japan. Architect of Record: Moriyama & Teshima Architects, Toronto, Canada.

2. Qur'an 24:35: "Allah is the Light of the heavens and the earth. The Parable of His Light is as if there were a Niche and within it a Lamp: the Lamp enclosed in Glass: the glass as it were a brilliant star: Lit from a blessed Tree, an Olive, neither of the east nor of the west, whose oil is well-nigh luminous, though fire scarce touched it: Light upon Light! Allah doth guide whom He will to His Light: Allah doth set forth Parables for men: and Allah doth know all things."

3. Letter from His Highness the Aga Khan to Fumihiko Maki, January 3, 2006.

4. Accessed at *www.pritzkerprize.com/1993/jury* on January 8, 2013.

5. Fumihiko Maki in conversation with Philip Jodidio, Zurich, October 16, 2012. The jury comment was: "This is a significant addition to Ottawa's repertoire of diplomatic buildings and puts Canadian architecture firmly on the world stage. Impressively monumental in scale, the project combines a powerful civic presence with a remarkable level of sophistication. Its integration of traditional Islamic motifs such as specially crafted screens and a lush courtyard garden is choreographed with assurance and sensitivity, bringing the building wonderfully to life as a delicate and sensual piece of architecture, while the quality of materials and detailing is outstanding." Accessed at *www.raic.org/honours_and_awards/awards_gg_medals/2012recipients/ismailiimamat_e.htm* on January 8, 2012.

6. Fumihiko Maki and Maki and Associates, *<Aga Khan Museum 007.02.17.pdf>*. Document provided by Fumihiko Maki to Philip Jodidio.

7. Fumihiko Maki in conversation with Philip Jodidio, Basel, Switzerland, May 13, 2008.

8. Fumihiko Maki in conversation with Philip Jodidio, Zurich, Switzerland, October 16, 2012.

9. *Ibid*.

10. Letter from His Highness the Aga Khan to Fumihiko Maki, January 3, 2006.

11. Fumihiko Maki in conversation with Philip Jodidio, Basel, Switzerland, May 13, 2008.

12. *Ibid*.

13. Fumihiko Maki in conversation with Philip Jodidio, Zurich, Switzerland, October 16, 2012.

14. His Highness the Aga Khan in conversation with Philip Jodidio, London, United Kingdom, March 6, 2007.

15. Letter from His Highness the Aga Khan to Fumihiko Maki, January 3, 2006.

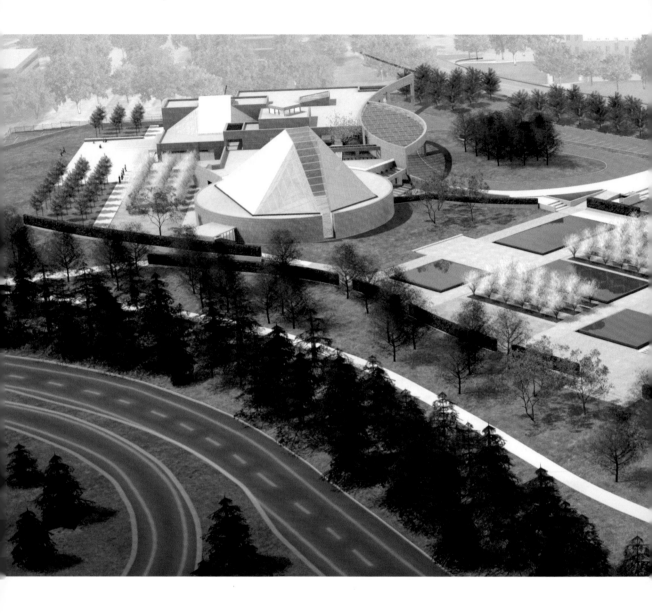

The Aga Khan Park: An Urban Oasis

D. Fairchild Ruggles

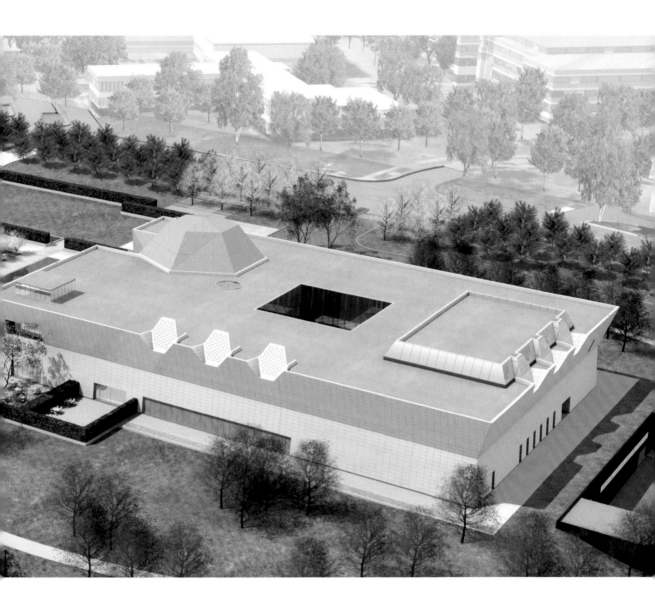

What is an Islamic garden in the twenty-first century? This is the question His Highness the Aga Khan has posed for designers and restorers of gardens and parks projects in Canada and around the world. It is the question that landscape architect Vladimir Djurovic sets out to answer in his stunningly modern design for the Aga Khan Park in Toronto. The Park contains the Aga Khan Museum designed by Japanese architect Fumihiko Maki, as well as the Ismaili Centre and prayer hall designed by Indian architect Charles Correa.

These singular buildings gaze at each other across large formal gardens that capture elements of each building and extend them into the outdoors. In designing a major

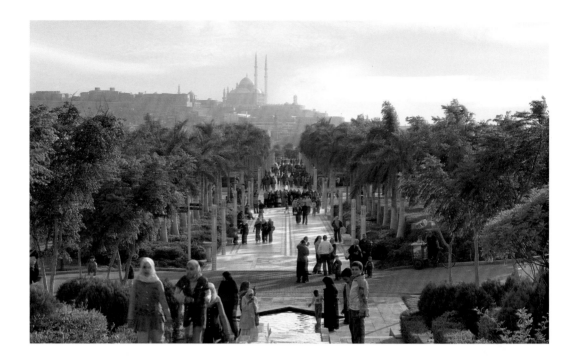

landscape site such as this, the architect had to consider practical issues such as traffic, pedestrian safety, parking, and water runoff—elements of design that escape notice when they work well, as they do here. But the striking beauty of the design is in its formal gardens at the heart of the Park. They are composed of a series of axial views directed across a tightly controlled series of horizontal ground planes, a visual experience that is enhanced by the sensory experience of scent and sound. In the design competition that led to the selection of Djurovic for this commission, the questions that the landscape architects had to consider were: What kind of Islamic garden is appropriate for Toronto today? And how can a garden designed for today echo the past while looking forward to the future?

The Aga Khan Park in Toronto takes its place in a constellation of twenty-first-century park projects commissioned by the Aga Khan Trust for Culture (AKTC). These include the cultural-ecological park set within a forested reserve on the outskirts of Mali's capital, Bamako, one of the fastest-growing African cities; the restored gardens at the Tomb of the Moghul emperor Homayun (built in 1571); al-Azhar Park in Cairo, Egypt, built on a former rubbish dump and comprising archaeological excavation, historic preservation, and a revitalization plan for the nearby low-income Darb al-Ahmar neighbourhood, setting a new standard for how such projects could stimulate jobs and improve the living conditions of residents; and in Kabul, Afghanistan, the restoration of the Moghul emperor Babur's sixteenth-century gardens, which combined attention to historic fabric with concern for the well-being of people living there today.

ABOVE: Built on a plateau rising above the old city, al-Azhar Park provides splendid views of Cairo, Egypt.

OPPOSITE TOP: The Bagh-e Babur project in Kabul, Afghanistan, features a restoration of the tomb of the Moghul emperor Babur as well as re-creations of the water channels, terraces, and fruit orchards of the sixteenth-century garden.

OPPOSITE BOTTOM: A fountain attracts children on a path leading from the entrance to the National Park of Mali in Bamako, the country's capital.

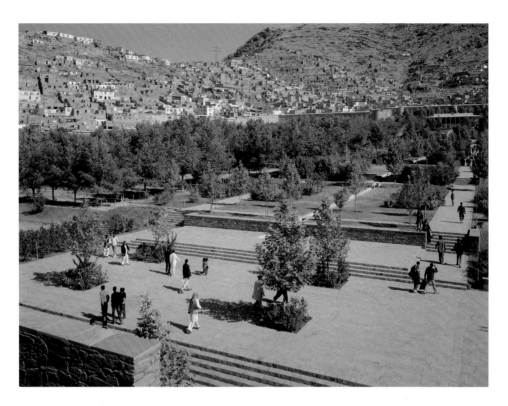

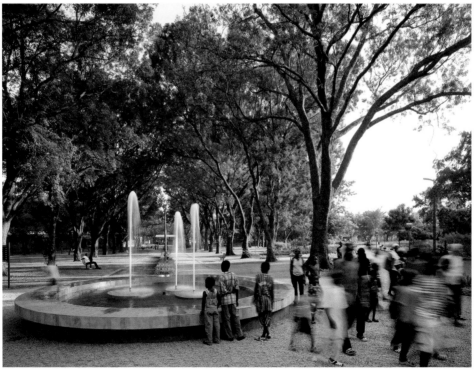

In Toronto the Aga Khan Park likewise has an ambitious goal of providing a place for beauty, culture, and education. The linchpin of the Park is the formal gardens that mediate between the Museum and the Ismaili Centre. Although the gardens stand as an independent design, Djurovic thought carefully about the character of each building and met with the architects personally. The result is coordination between the three-dimensional architectural volumes and the landscape. The formal gardens are laid out with large-scale pools and terraces to match the majestic proportions of the buildings. There are moments when the consonance is striking as, for example, from inside the Museum's entrance hall where a viewer who pauses to look back through the glass wall sees the distinctive pyramidal roof of the Ismaili Centre. The hall flows as a continuous volume out into the gardens where it pauses midway at a rectangular pool in which from one side the Centre's pyramidal roof again appears, this time as a reflection, while from the other side, it is the Museum that is caught on the water's surface.

The effect seems magical, yet it is entirely intentional. For the large pools, Djurovic chose dark granite to better capture reflected images so that, in his words, "everything is there but not there" by virtue of the reflection. He describes the pools as "five pure mirrors to capture the sky, trees, Museum, and the pyramidal roof of the Ismaili Centre's prayer hall."[1]

The formal gardens are laid out as a series of flat planes. The horizontal surfaces of the shimmering pools are divided by broad walkways that pass through stands of serviceberry trees (*Amelanchier laevis*) that themselves have a regular shape and even height. The visual effect is not of casual clumps of vegetation but geometrical blocks of orchard that at maturity will reach a consistent height of nine metres. Despite its consistent appearance, this horizontality is not a natural characteristic of the site; it is achieved by tight control of the natural landscape and paying attention to its contours. Djurovic's previous work reveals his love for the horizontal plane, notably his award-winning, small-scale works in Beirut where pools, and even stepped pools of water, are used to assert horizontality.

There are hidden secrets in the formal gardens. To discover them, one must visit the Park throughout the year to catch the changing displays of colour, texture, fragrance, and even sound. The colours can be dramatic, and they change from season to season. A stand of dogwood trees (*Cornus kousa*) near the Ismaili Centre provides a show of white petals in the spring, brilliant red berries in the summer, and foliage that turns red in the fall. Drifts of flowering bulbs are planted in the understory of the various tree groves to inaugurate the spring season. Plantings of magnolia (*Magnolia* x *soulangiana* and *Magnolia stellata*), burning bush (*Euonumus alatus*), hydrangea (*Hydrangea quercifolia* and *Annabelle Hydrangea*), butterfly bush (*Buddleia davidii*), and weigela

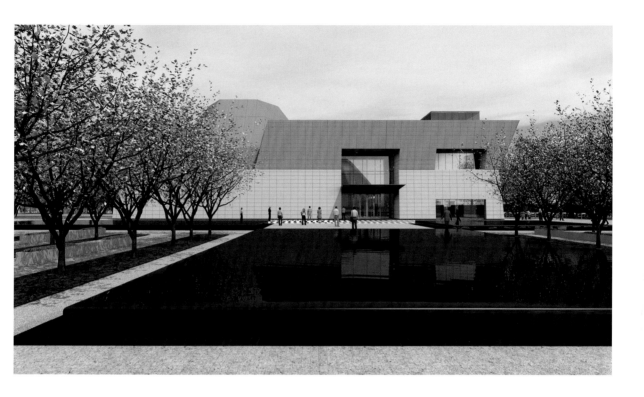

(*Weigela florida*) contribute to the constantly changing cycle of colour. Bordering the lawn on the western side, a large bed of roses (*Rosa* spp) has dense foliage and in the late spring and summer bursts into bloom with five-petalled pink and white flowers. In the fall the maple trees that surround the site blaze with colour.

The trees, shrubs, and plants were chosen for their fragrance and multi-sensory appeal. The rose blooms have a lovely scent in the summer, followed by bright orange-red rosehips later in the season, adding fresh colour to the gardens as well as attracting birds, who like the plump, tart seed pods. The rosehips cling through fall and winter, a visible memory of the cycle of flowers-to-fruit. The roses are one of many gestures to Muslim tradition, for historically the scent of the rose was associated with the Prophet Muhammad, whose sanctity caused him to smell sweet.[2]

Similarly, the serviceberry trees in the centre of the formal gardens have a spreading, multi-trunked body with white blooms in the early spring, followed by tasty berries that emerge as pink but darken to deep purple by summer's end. In the fall the leaves turn red, transforming the formal gardens into a tumult of colour. Thyme is planted

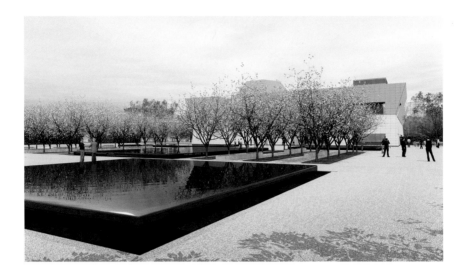

underneath, an herb that offers both the colour of its tiny white, pink, and lavender flowers as well as the pungent scent of its leaves.

The edible rosehips and fruit of the serviceberry attract birds, whose trills and chirps, in time, will fill the Park. As a constant rhythmic accompaniment to the birds' songs, water splashes from the pools into deep channels that run below and around their edges. The pools were designed to enhance the sound of the water, with the pools' lips bevelled so that the water does not simply slide over the edges but falls noisily into the channels.

When the Museum opened, many of the trees—especially those in the formal gardens at the Park's centre—were already fairly large. The story behind them reveals Djurovic's attention to detail. The design for the Park was accepted by the Aga Khan in 2008 and called for a great many trees. Djurovic had the idea of buying many of them in advance, and North American nurseries had trees on sale in 2008 due to the recession. The strategy had two benefits: first, the trees were purchased at affordable prices when nurseries needed customers; and second, the trees had time to grow and mature

ABOVE: The serviceberry trees in the Aga Khan Park, as seen in this artist's rendering, will have white blossoms in the early spring, while the larger honey locust trees to the right of the Aga Khan Museum stand in a circular island of stone mosaic.

BELOW: An artist's rendering of the reflecting pools in the Aga Khan Park.

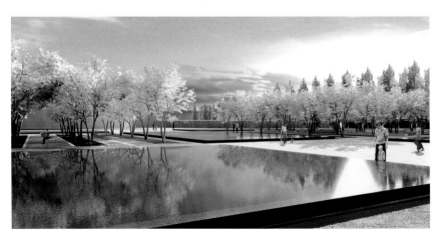

on-site during the construction phase. Consequently, when the Park was ultimately built in 2013–14, it had the unusual luxury of featuring large specimens. The fortuitous result is that the Park appears not as an emerging idea but as an already formed garden.

In this modern space of smooth planar surfaces, clean geometry, and sensory delight, what is it that recalls the traditional character of an Islamic garden? And how can a landscape designed today reflect past values in a sensitive manner yet be freed from constraints that such a backward glance might impose? Vladimir Djurovic thought carefully about these questions when he began designing the Park almost ten years before it was completed and open to the public.[3] He could draw on past experience, growing up in Lebanon (the son of a Lebanese mother and a Serbian father) and designing

Vladimir Djurovic's Samir Kassir Square in Beirut, Lebanon, offers a tranquil respite in a city that has known more than its share of strife.

for patrons in the Middle East and North Africa in some of his earlier commissions. In addition to award-winning private residential gardens in Dubai and Lebanon, he won the Aga Khan Award for Architecture in 2007 and an Honor Award from the American Society of Landscape Architects in 2010 for his design of Samir Kassir Square (completed in 2004) in Beirut.

When the Aga Khan encouraged Djurovic to tour major Islamic gardens to deepen and expand his knowledge of history and of his own cultural roots, he visited and was profoundly influenced by two gardens in particular: the Tomb of Homayun in Delhi and the Alhambra's courtyard gardens in Granada, Spain. Each offered him a different kind of inspiration.

Built in the fourteenth century, the Alhambra's Court of the Myrtles is a peaceful courtyard with a large, deep pool of water flanked by rows of myrtle shrubs. The composition is simple, yet its impact is extraordinary: the water's silvery surface reflects the surrounding architecture of delicate stucco and columnar arcades, while at either end of the rectangular pool, round basins contain water jets that leap upward before falling gently into the pool. Djurovic marvelled at the dematerialization of surrounding form and ornament in the Court of the Myrtles where "everything dissolves." He captures the minimalism of water and vegetation and the same wonderment in dematerialized form in his composition of reflecting pools in the Aga Khan Park's formal gardens.

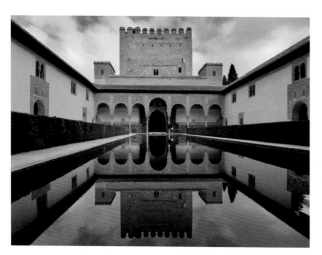
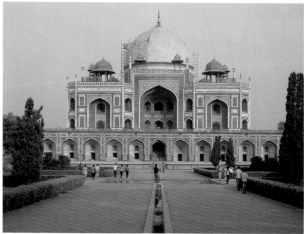

Homayun's Tomb offered a different experience. The sixteenth-century Moghul garden site consists of a huge domed tomb that stands at the centre of an enormous enclosure divided axially into a classic *chahar bagh* (four-part garden). Although largely flat, the ground, in fact, has just enough change in level to allow small water cascades to splash into recessed basins, introducing pleasant sound into the immense space and keeping the water moving and fresh. This grand imperial garden has become a popular park where Delhi residents and visitors seek calm refuge from the busy city. Thus, in its present form, Homayun's Tomb emblematizes one of the challenges that faced Djurovic: how to translate a cultural tradition that was designed for an elite set of patrons into modern terms for modern audiences.

Ever since the earliest palace gardens were wrought from the arid conditions of the deserts of the Middle East in the seventh century, the Islamic garden was a place of lush vegetation, repose, and leisure, as well as an expression in intimate detail of all the processes by which humankind makes the earth hospitable and productive. As gardens evolved, their shade was equated with the promise of paradise, a place of rest and pleasure. The fruit-bearing trees and plants likewise were understood to provide a foretaste of the heaven to come. The water on display and the vegetation were signs of a divine blessing from "He who sends down water from the skies, and brings out of it everything that grows" (Qur'an 6:99). However, it was a blessing conferred on a people who had worked to make the earth habitable and fruitful, the primary signs of which were the well-tended and irrigated agricultural landscape and the refined garden that was a metaphor for that larger landscape.[4]

Basic processes of the working landscape gained special meaning: the well from which water was laboriously lifted by buckets in the desert was represented in the garden as a gushing fountain; the irrigation canal became the ornamental water channel; the organization of the landscape into plots, each cultivated by a different farmer, was abstracted into the four-part garden plan. A landscape of human labour was thus

ABOVE LEFT: In Granada, Spain, the Alhambra's fourteenth-century Court of the Myrtles provides a peaceful environment for contemplation and reflection.

ABOVE RIGHT: The Moghul emperor Homayun's sixteenth-century tomb in Delhi, India, stands at the centre of an enormous enclosure divided axially into a classic *chahar bagh* (four-part garden).

transformed into an ideal place, one that was enjoyed on earth by only a very few, while imagined and desired by the rest. In Islamic history the garden thus became one of its primary art forms, having the combined ability to represent the critically important relationship between humankind and nature, as well as developing as a form that provided a sensory foretaste of the gardens of paradise that awaited the faithful.

Historically, most earthly gardens were places that could be enjoyed by only the most elite members of society who alone had the means to commission them and the leisure to enjoy them. This is in striking contrast to the twenty-first century, when the garden is more likely to be a public park, a college or hospital campus, a hotel courtyard, or a children's playground open to all. Those gardens, like the Park of the Aga Khan Museum, invite visitors to stroll about, to savour fragrances, to rest and contemplate, to gaze and reflect, or to find a private corner in which to sit quietly and enjoy the sights and sounds of the flowers, water, and birds. Djurovic wanted to create a space that "unifies without alienating or segregating, and a serene environment where contemplation finds spirituality." It is a place for solitude but also conviviality and conversation. In this sense of welcoming everyone, the modern urban park—and in particular Toronto's Aga Khan Park—may be the quintessential built form of the new millennium.

Just as the Islamic gardens of the past had recognizable forms, purposes, and meanings, the modern world is endowing the contemporary Islamic landscape with new forms, purposes, and meanings. Whether built in Cairo, Kabul, or Toronto, these sites present challenges to the designer: how to evoke the style and history of the Islamic gardens and parks without being inextricably bound by their forms and values, and how to create a park in cosmopolitan Toronto that reflects a tradition of royal and imperial Islamic gardens yet serves a new global clientele seeking art, education, and engagement with nature and each other. In the twenty-first century, space matters—especially the public spaces where modern, civil society gathers—and these are important questions.

Notes

1. Quotations throughout are from an interview conducted by D. Fairchild Ruggles and Ruba Kana'an with Vladimir Djurovic, May 16, 2013.

2. Maria Subtelny, "Visionary Rose: Metaphorical Application of Horticultural Practice in Persian Culture," in *Botanical Progress, Horticultural Innovation and Cultural Change*, ed. Michel Conan (Washington, DC: Dumbarton Oaks,

2007), 13–34 (see n. 25).

3. Philip Jodidio, "A Garden in Toronto: The Design of Vladimir Djurovic," in Philip Jodidio, *The Aga Khan Museum, Toronto* (Munich: Prestel, 2008), 82–101.

4. D. Fairchild Ruggles, *Islamic Gardens and Landscapes* (Philadelphia: University of Pennsylvania Press, 2008), 89–101.

Highlights in the Permanent Collection

Ruba Kana'an

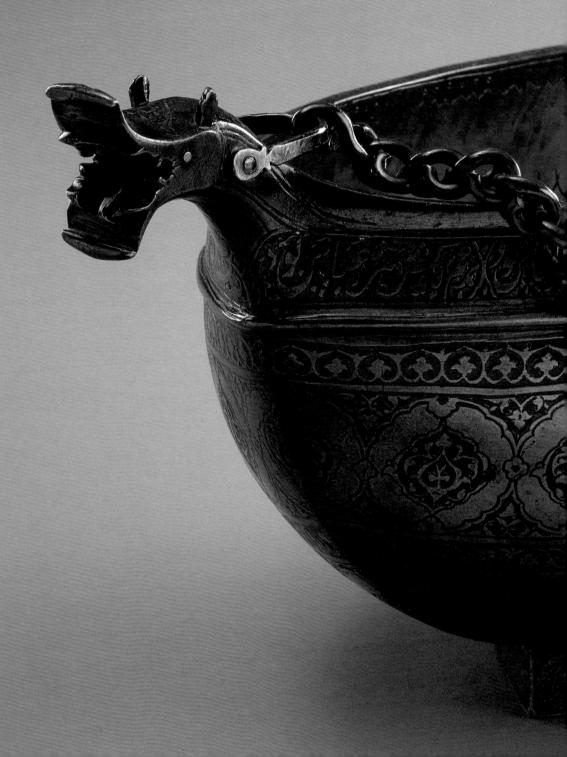

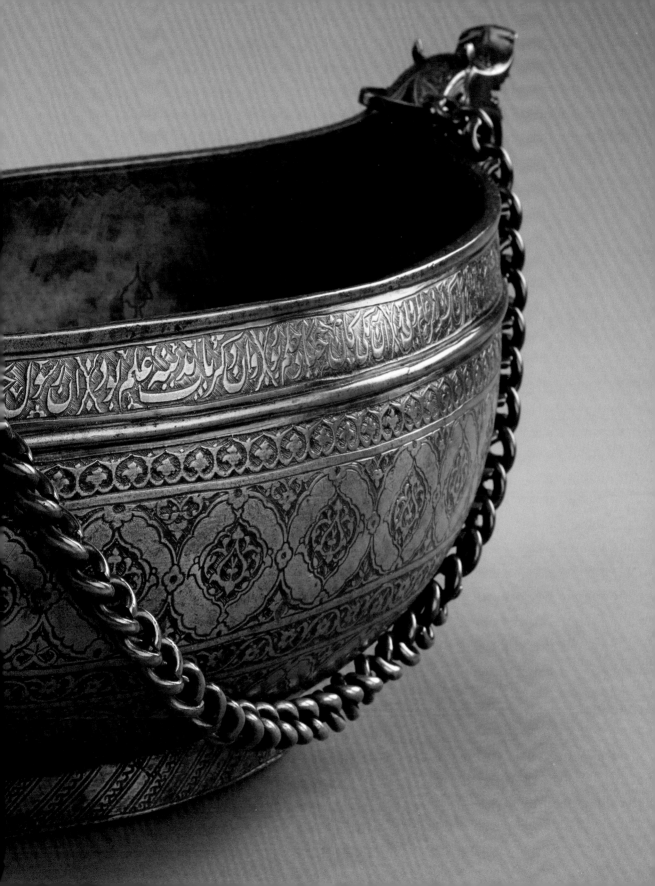

Qur'ans

Detail of Qur'an
(see page 50)
Copied by
Mahmud Sha'ban
Gwalior Fort,
India (Historic
Hindustan), 1399
Ink, opaque
watercolour, and
gold on paper
Folio: 28.9 ×
22.2 cm
AKM281

The Qur'an is regarded by all Muslims as the Word of God—the sacred text that serves as the foundation of their faith and practice. It was revealed in Arabic to the Prophet Muhammad (died 632) through the Archangel Gabriel. During the lifetime of the Prophet, verses of the Qur'an were transmitted orally and written down on various materials such as parchment, bone, and stone. The compilation of the Qur'an into the current codex took place under the direction of 'Uthman (died 656), the third caliph. The shift to copying the Qur'an on paper came much later, with the earliest surviving paper copy dating to the end of the tenth century. The transition from parchment to paper is also reflected in the format of the codex, since parchment Qur'ans were usually smaller in size and copied horizontally, while paper allowed for a variety of sizes and vertical formats.

The Qur'an has 114 chapters, known as suras, each dealing with a number of topics. In addition to its central message of faith and ethics, the Qur'an also contains histories, parables, and stories that have inspired the arts. The suras of the Qur'an are arranged according to their length: the longest suras appear at the beginning of the Qur'an, whereas the shortest appear at the end. Muslims copied the Qur'an in single volumes (AKM281) or designed the copy to be bound in several volumes or divisions known as *juz's*. The most common divisions were seven or thirty *juz's* (AKM279 and AKM829).

This section illustrates some of the Aga Khan Museum's finest Qur'an manuscripts, focusing on two interconnected aspects of the art of the Qur'an: the evolution of the Arabic script used for copying Qur'ans and the ensuing importance of the art of calligraphy (see pages 126–37); and the evolution of the art of decorating Qur'ans with geometric and floral designs, known as illumination.

Early Qur'ans were written in an angular script known as Kufic, characterized by an emphasis on horizontal lines and short vertical strokes. Additional markers, mostly in the form of dots, were used above and below the text line to indicate vocalization. By the tenth century, new styles of cursive script that were faster to write and easier to read evolved. These standard styles include the six canonical scripts of Arabic calligraphy: *naskh*, *thuluth*, *muhaqqaq*, *tawqi'*, *riq'a*, and *rayhan*.

Unique regional variations on these cursive scripts were used in China (AKM824) and the Indian subcontinent (AKM281).

Copies of the Qur'an were commissioned by benevolent rulers and gifted to mosques locally and in faraway regions (AKM475). Rulers and patrons considered the endowment of beautifully copied Qur'an manuscripts with state-of-the-art decoration and magnificent leather binding as an act of piety. The art of decorating the Qur'an with intricate borders of geometric and floral designs thus became a prominent art (AKM256). These illuminations reveal changes of style over time; they also reflect regional artistic traditions in which Muslims chose to copy and decorate their sacred text (AKM488).

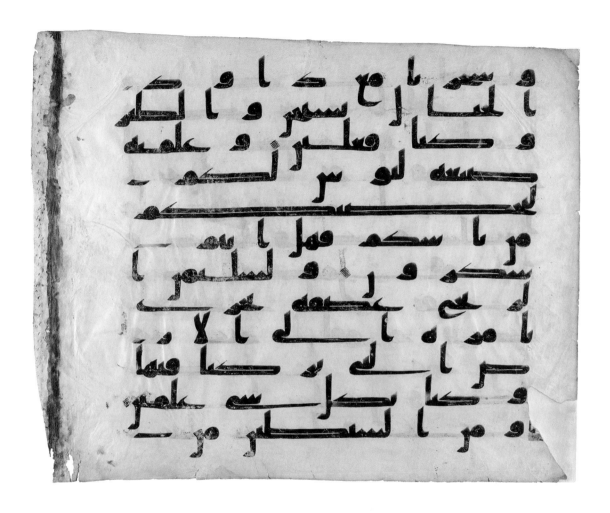

Qur'an Folio

(Q21:76–82)

North Africa, 8th century

Ink on parchment

58.5 × 71.5 cm

AKM475

With the spread of Islam out of Arabia, Muslim rulers sent copies of the Qur'an to new urban centres of Muslim congregation. This gesture was meant as a symbolic reference to the caliph's role as the custodian of faith, as well as to impress the receivers with the beauty and monumentality of these Qur'ans. Here, the text appears quite simple and unadorned. The Kufic script is evenly spaced using horizontal elongation of letters (*mashq*) and dashes at the end of the line (on the left) to achieve a justified text block. Indeed, the whole of the fifth line is a single word. What would have been most impressive for the eighth-century community to which this Qur'an was sent, however, is the fairly large size of the parchment (see also AKM238, page 46) on which it is copied and the number of its folios. This monumental Qur'an, most of which is now in Tashkent, Uzbekistan, was probably one of the most expensive to be produced in the second half of the eighth century.

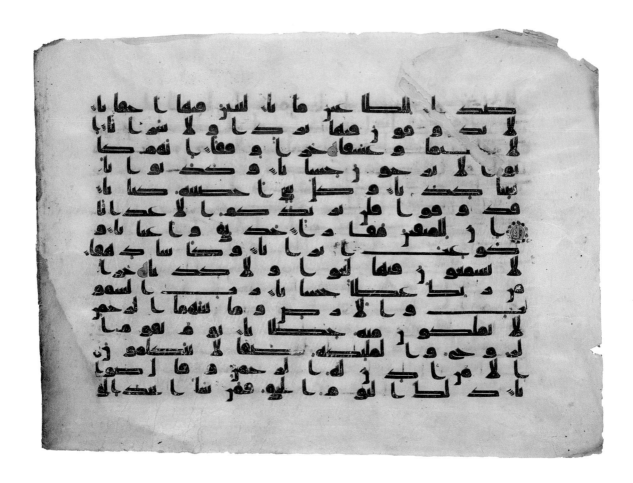

Muslims discovered the secret of papermaking after the Battle of Talas in 751 when the
Abbasids (750–1258), ruling from Baghdad in present-day Iraq, and the Tang dynasty
(618–907), ruling from Xi'an in China, battled for control of Central Asia. Their first use
of paper, however, was reserved for administrative documents. Until the end of the tenth
century, Qur'ans, like this ninth-century folio, were still being copied on parchment, an
animal skin that is stretched, limed, and scraped to produce a uniform writing surface. The
fifteen lines of Kufic script in this folio are interrupted by four oblique strokes that indicate
the end of each verse, with a letter marker filled with gold after each fifth verse. The dia-
critical marks are indicated with red ink dots that add a pleasant decorative element to the
uniform black ink of the text.

Qur'an Folio

(Q78:1–38)
Iran or Iraq, 850–900
Ink and gold on parchment
61 × 45.6 cm
AKM238

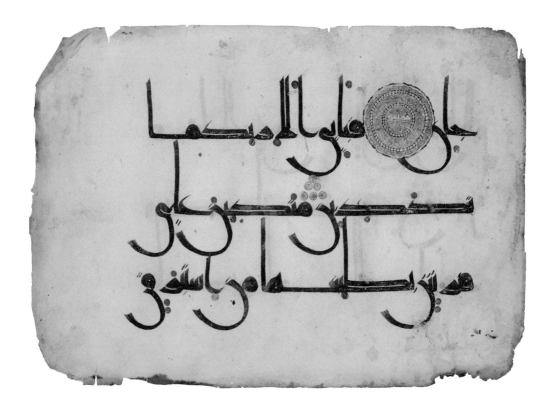

Qur'an Folio

(Q55:52–54)

North Africa, 10th century

Ink and gold on parchment

23.8 × 33.1 cm

AKM482

This elegant folio is from a dispersed Qur'an manuscript that must have been magnificent to see and costly to produce. Each side of the parchment has three lines only, suggesting that the complete manuscript was enormous. The text is written in a Kufic script with distinctive features such as the emphasis on the vertical letters and the swooping tails of the final curved letters that later became a hallmark of the *maghribi* script known from Spain and North and West Africa. The red and green dots in the text are early examples of vocalization markers, mostly indicating *hamzas* and long vowels. The end of each verse is signified by six gold dots in the form of a triangle, with each fifth verse marked by a decorative circle.

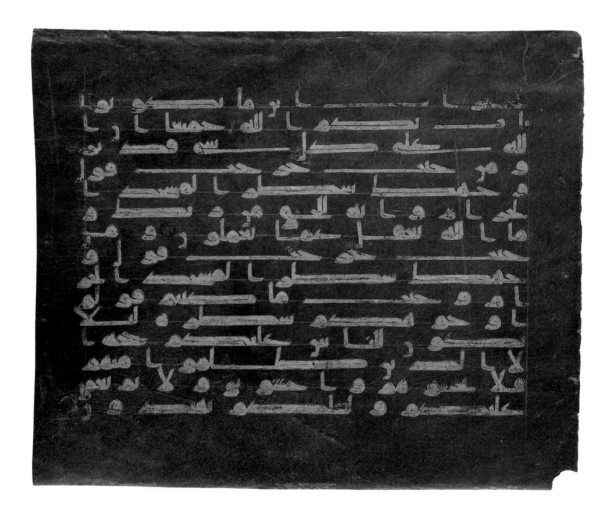

The dispersed "Blue Qur'an" to which this folio belongs is one of the most famous surviv-
ing Qur'an manuscripts. The text of this outstanding Qur'an is copied in gold ink outlined in
black on a deep indigo-blue parchment. Small silver rosettes (now oxidized) punctuate the
flow of the text at the end of each verse and add a decorative element to an already spec-
tacular folio. Although rare in Qur'an manuscripts, the gold-on-blue aesthetic was used in
royal manuscripts in the courts of the Abbasids (750–1258) and the Fatimids (909–1171).
It can also be seen in the mosaic inscriptions of the Dome of the Rock in Jerusalem, dating
to 692, and known from the literary descriptions of the mosaic inscriptions in the earliest
mosques in Medina and Damascus. Around a hundred leaves from this Qur'an are known
from museum and private collections, including a section in Mashhad, Iran, and sixty-seven
pages in a museum near Qayrawan, Tunisia.

Qur'an Folio
(Q2:148–150)
North Africa, Iraq, or Iran,
9th–10th centuries
Gold and silver on
blue-dyed parchment
28.5 × 35.3 cm
AKM248

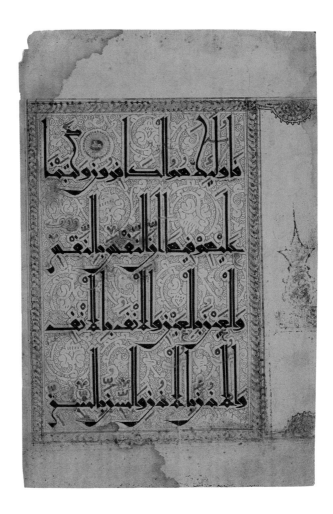

Qur'an Folio

(Q5:44–45)
Iran, mid-12th century
Ink, opaque watercolour,
and gold on paper
31 × 20.8 cm
AKM256

By the time this magnificent folio was copied in eastern Iran, the use of paper in a vertical format and the full pointing and vocalization of the text were already established standards (except in Spain). Here, all pointing and diacritic marks are written in the same ink and hand as the letterforms, while the vocalization is rendered in red, most probably after the text was copied. However, it is the design and layout of the folio that are most magnificent. The generous spacing between the lines and the graceful verticality of the uprights of the letters create a rhythm for the full decoration of the background. An ornamental palmette-scroll (arabesque) outlined in blue surrounds the text and takes pride of place on the page, with a miniature tight scroll filling the space in between. The gilded braid framing the page and the marginal finials give it a sophisticated finished look. It would have been an elaborate under-taking by a wealthy patron to commission and complete this thirty-volume dispersed Qur'an. Scholars have estimated that this Qur'an would have had approximately 4,500 pages, some of which are in prominent museum collections.

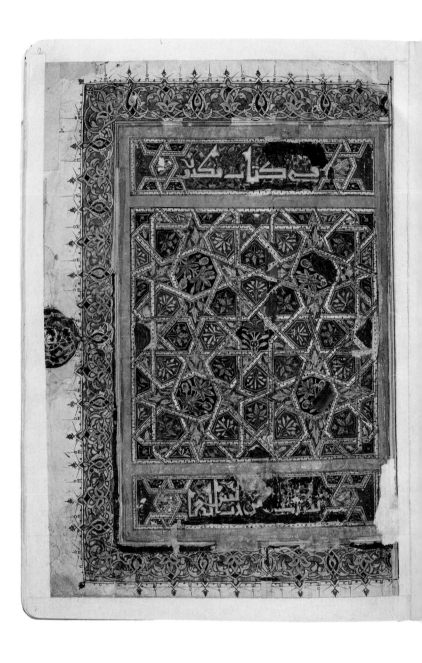

Copied under the Tughluqs (1320–1414) who ruled parts of present-day India and Pakistan before the Moghuls (1526–1858), this unique Qur'an is one of the earliest surviving manuscripts in the *bihari* script. Known as the Gwalior Qur'an after the Gwalior Fort where it was copied, this Qur'an is testimony to the active diplomatic networks and cultural and economic interactions in the fourteenth and fifteenth centuries. Although the *bihari* script, which was common in pre-Moghul India, is a unique variation on *naskh*, the decorative features of the Gwalior Qur'an bring together elements from Mamluk (1250–1517)

Qur'an

Copied by Mahmud Sha'ban
Gwalior Fort, India (Historic
Hindustan), 1399
Ink, opaque watercolour,
and gold on paper
Folio: 28.9 × 22.2 cm
AKM281

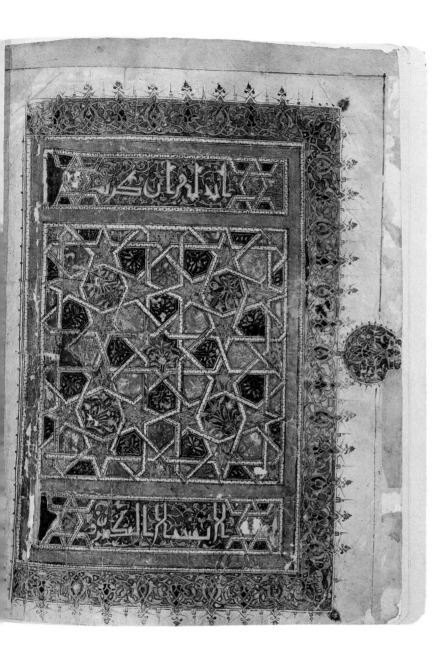

and Ilkhanid (1256–1353) layouts and illuminations as well as the exuberance of Indian painting conventions. The strapwork design of this spectacular opening page, for example, recalls the elaborate Qur'an illumination celebrated under the Mamluks. Also significant is the use of interlinear translation where verses in the original Arabic in which the Qur'an is copied, memorized, and recited are translated into Persian in a smaller *naskh* script.

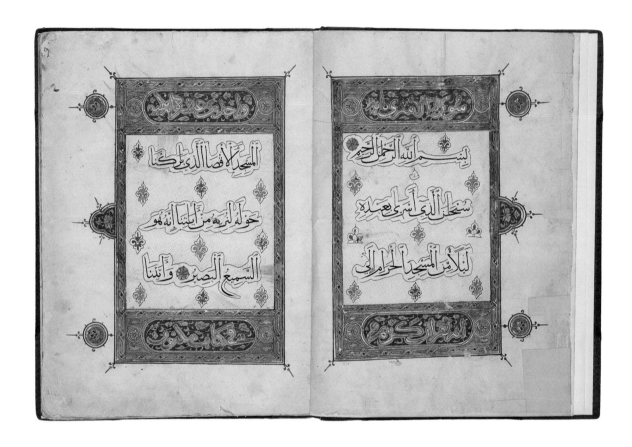

Qur'ans copied under the Mamluks, who ruled in Syria and Egypt between 1250 and 1517, were mostly commissioned by sultans or their officials as endowments (*waqf*) given to elaborate architectural complexes that were established to house religious and charitable foundations. Some of these Qur'ans, like this section (*juz'*), were copied in multiple volumes. This *juz'* from a late fourteenth-century Qur'an demonstrates a typical layout with a lavishly illuminated opening page followed by simpler text pages where the decoration is limited to verse markers. The gold-filled elaborate braid that frames the three-part division of the opening pages indicates a wealthy, if not royal, patron. An inscription on the leather binding suggests that this Qur'an was copied for the religious complex of the Mamluk Sultan al-Zahir Barquq, who ruled intermittently between 1382 and 1399.

Qur'an *Juz'*

Cairo, Egypt, 14th century
Ink, opaque watercolour,
and gold on paper
Folio: 37.2 × 27.3 cm
AKM279

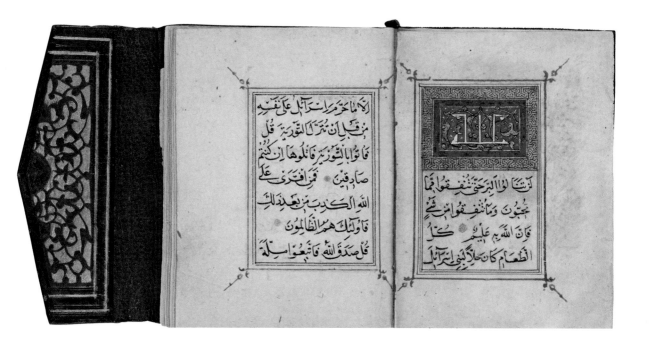

Qur'an *Juz'*

Iran, mid-15th century
Ink, opaque watercolour, and
gold on paper, leather binding
Folio: 6.6 × 4.7 cm
AKM829

Dividing the Qur'an into thirty sections enabled Muslims to memorize or recite an individual section each day, especially in the fasting month of Ramadan. Each section, called *juz'*, was a separate volume, as is the case in this *juz'* that was copied under the Timurids, who ruled in Iran and Central Asia between 1370 and 1507. This palm-size Qur'an *juz'* got the full attention that would have been given to a large, elaborate manuscript. Its forty-two pages, each with seven lines, are written in a crisp cursive *naskh* script, the text is outlined with a simple decorative border, and the heading is intricately illuminated. The quality of the leather binding, however, is what is most remarkable about this small Qur'an. The binding has cartouches with gilt and stamped designs on the outside and cut filigree on the inner face of the binding (doublures), rendering this Qur'an truly exceptional.

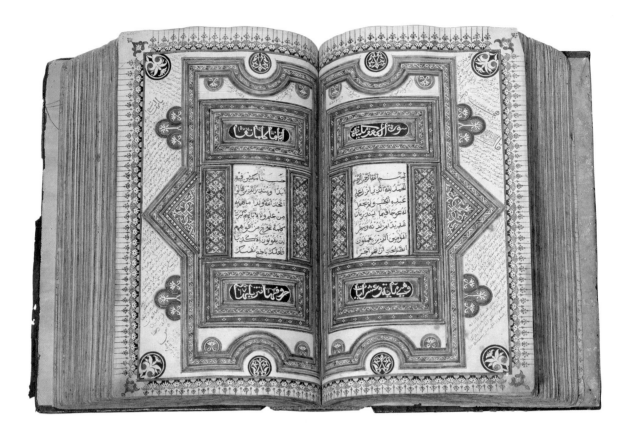

This rare example of a complete and finely illuminated Qur'an from Sulawesi Island in Indonesia is a magnificent example of the localized artistic traditions in which Muslims chose to copy and decorate their sacred text. The Qur'an has three fully illuminated spreads with complex geometric illuminations in red, black, brown, ochre, and reserved white. What is most interesting here, though, is that in addition to the usual markers at the end of each verse, and the distinctive marker on every fifth verse, this Qur'an has marginal markers in a variety of circle and rosette forms to indicate other points of interest, including the middle of the Qur'an and the beginning of each *juz'*. It also includes an extensive amount of marginalia on recitation variances, grammar, and interpretation.

Qur'an

Copied by Isma'il b. 'Abdallah Makassar
Sulawesi Island, Indonesia, 1804
Ink, opaque watercolour, and gold
on paper
Folio: 34.5 × 21.5 cm
AKM488

The fluid brushlike strokes of this calligraphic composition are written in the striking *sini*
script developed in China by Muslim calligraphers. The folio on the right has the Qur'anic
phrase *subhan Allah* ("glorious is God") set in a background floral spray. The sweeping
letterforms and particularly thin uprights seem to derive from a monumental *thuluth* script
that was clearly adapted to a Chinese visual aesthetic in its *sini* form. The manuscript con-
tains a compilation of Qura'nic suras and illuminations, including the decorative roundel, on
the left, with a Chinese symbol of good luck at its centre. Islam spread to China from the
middle of the seventh century mainly through trade and diplomatic exchanges.

Qur'an Anthology

China, second half of 18th century
Ink, opaque watercolour, and gold
on paper
Folio: 27.5 × 20 cm
AKM824

Qur'an Scroll

Copied by Zayn al-'Abidin Isfahani
Iran, 1847
Opaque watercolour, gold, and ink
on paper
575 × 12.5 cm
AKM492

This magnificent Qur'an was copied in 1847 on a narrow paper scroll that is more than five metres. The minute script employed here is known as *ghubar* (literally, "dust"). It is a miniature form of *naskh* that seems to have originally developed to transcribe messages transferred by carrier pigeons. Employing *ghubar*, in this case, provides the opportunity to copy the whole Qur'an in an easily portable form while creating a pleasing visual effect. The text is copied in a manner that leaves a pattern of cartouches in reverse, some forming Qur'anic verses in a larger script. An elaborate decorative panel, to the right, and a simple blue-and-gold outline, frame the whole composition.

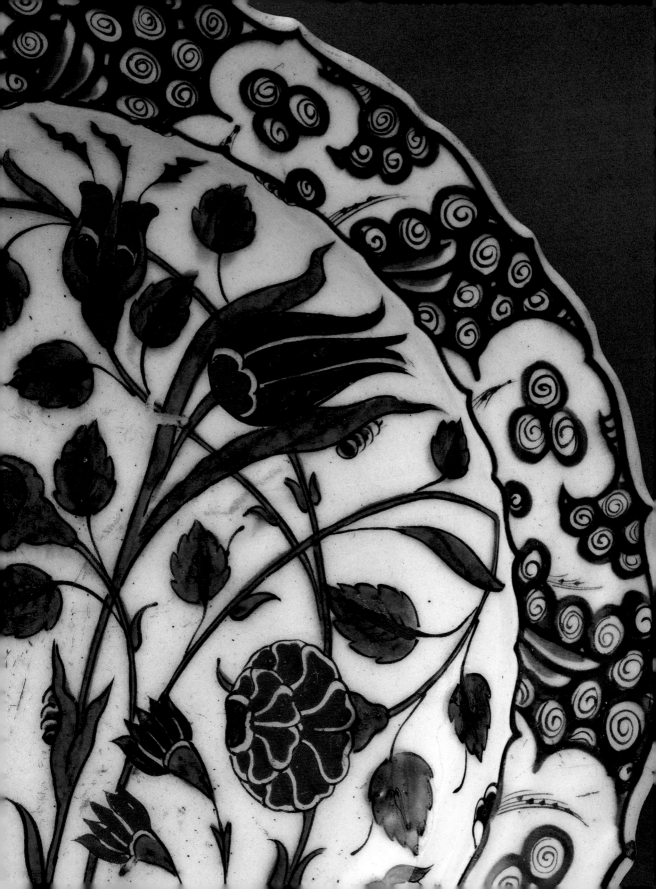

Ceramics

The thousand years of ceramic history represented here from the Aga Khan Museum collection demonstrates the creative efflorescence of Muslim artists and craftsmen and their ability to adapt to new styles and techniques. This selection purposefully illustrates the diversity of ceramics produced throughout the various regions of the Islamic world during different historical periods.

The development of glazing techniques rendered the body of the earthenware object impervious, but it was also a catalyst for human creativity. Whether clear or coloured (AKM562), transparent or opaque, these glazes opened up the possibilities of turning everyday ceramic objects into art canvases. In some cases, glaze formed a background for an elaborate decorative style that utilized minerals with a golden lustrous sheen (known as lustre ceramics) to create intricate compositions (AKM556 and AKM684). Clay itself was also used as part of the decorative process when thin layers of coloured clay, known as slip, were employed to create bold designs (AKM541) under clear glaze.

The production of a broader variety of ceramic forms and decorative styles from the eleventh century onward owed a large debt to the use of fritware (also known as stonepaste) as the chosen material for ceramic objects in Egypt, Syria, and Iran. Fritware was suitable for a number of creative opportunities such as the application of moulds for objects with complex forms. Its whitish colour and dense body allowed for intricate renditions of images and inscriptions on these ceramics reflecting the refined literary sensibility of patrons (AKM557).

Both pottery makers and their patrons responded to evolutions in style that were either reactions to local changes in tastes and trade patterns or the result of new imported fashions and motifs. The trade and diplomatic relations between China and the Muslim world, for example, had a major impact on the ceramic industry. Since the white clay (kaolin) of Chinese porcelain with its compact body and translucency was not available in Muslim centres of ceramic production, potters adapted the Chinese technique to create a whitish layer on their earthenware that emulated the visual effect of porcelain, then used this background as a canvas for their own designs (AKM546). Later encounters with Chinese imports led to the introduction of new motifs (AKM786) and new designs (AKM588).

Detail of Dish
(see page 69)
Iznik, Turkey,
1570–80
Fritware,
underglaze-painted
Diameter 34.3 cm,
height 7.4 cm
AKM687

59

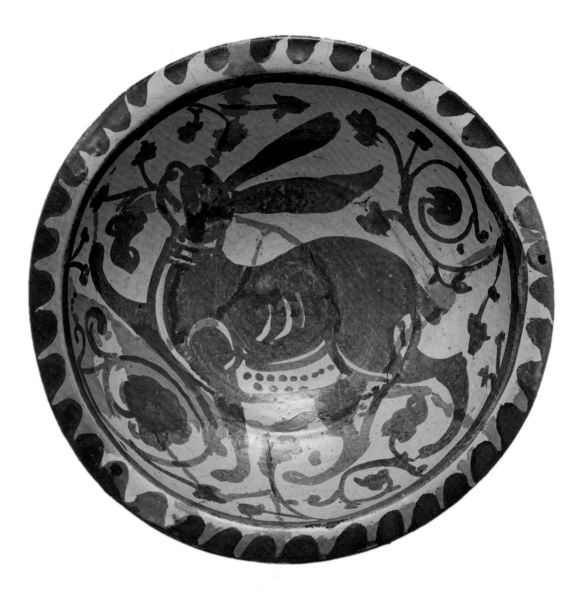

By the tenth century, the Fatimid capital of Cairo became the centre of production for ceramics that were decorated in a metallic paint that had a golden lustrous sheen (known as lustre ceramics). The striking visual compositions on these ceramics portray men and women, animals, and acrobats painted in fluid lines and lively naturalism. The jovial long-eared hare in the centre of this bowl is one of the many animals that appear on textiles, wood, ivory, and ceramics from the Fatimid period. The everyday nature of the depicted scenes and the golden tone of the lustre sheen set them apart from the earlier lustre ceramics in Iraq and later examples from Iran, both of which are represented in this selection from the Aga Khan Museum's collection. This type of Fatimid lustre bowl was highly appreciated as an export product throughout the Mediterranean, and several bowls can still be seen decorating the exterior walls of churches in Pisa, Italy, from the late eleventh and early twelfth centuries.

Bowl

Egypt, 11th century
Fritware, lustre-painted
Diameter 19.4 cm, height 6.6 cm
AKM684

Dish

Neyshabur, Iran, 10th century
Earthenware, underglaze slip-painted
Diameter 35.6 cm, height 12.7 cm
AKM740

This exceptional dish with its broad splashes of ochre, green, and brown glazes over a white background with an incised pattern is as pleasing to the eye as it is probing to the intellect. The similarity of its splashing effect and colours to the splash-painted wares (*san-ts'ai*) of the Tang dynasty (618–907) led to the assumption that this style was directly influenced by imports from China into the Abbasid realms of Iraq and Iran. Indeed, there is ample evidence that during the ninth century, potters in Abbasid Iraq tried to emulate the forms and visual effect of imported Chinese porcelain, which led them instead to use tin glaze to create a white background on earthenware. The Chinese splash-painted ceramics, however, were mainly developed as figurines and tomb goods and were not utilized in daily life. There is also no evidence they were ever exported to Iran where this intriguing dish was made. Could this be a case of exchange of ideas for which we have lost the evidence, or could it be the result of simultaneous development in design and glazing techniques?

The graceful design on this dish displays two aspects of the arts of Iran and Central Asia in the historical context of the tenth century: the prominence of literature and artistic creativity. The survival of objects, such as this dish, that are decorated with poetic and literary inscriptions both in Persian and Arabic coincided with the blossoming of Persian literature in Iran and Central Asia, including the works of great poets such as Rudaki (died 940) and Ferdowsi (died 1020). The aphorism, inscribed here in Arabic, reminds the viewer that "Generosity is the disposition of the dwellers of Paradise." This style of calligraphic pottery decorated with blessings, quotations from Hadith, and general aphorisms represents a most creative use of design and techniques. The placement of the inscription with its elongated letters on the sides or cavettos of the pottery and the striking contrast between the inscription and the background provide a pleasing rhythm and balance to the decorative composition. Both the white background and the black and red colours are layers of thin clay that were used to paint the composition under a layer of transparent glaze.

Dish

Iran or Central Asia, 10th century
Earthenware, underglaze slip-painted
Diameter 34.9 cm
AKM546

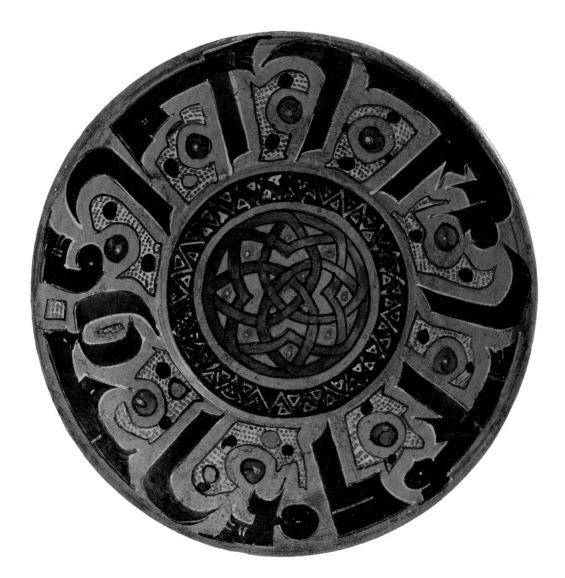

Dish

Northeast Iran, 10th century
Earthenware, underglaze slip-painted
Diameter 32.8 cm

AKM541

Similar to the aphorism on AKM546, the one decorating the rim of this dish also reads "Generosity is the disposition of the dwellers of Paradise." Also comparable is the method in which the dish is made and decorated with thin layers of coloured clay. But here the similarities end. The calligraphic composition on this dish is painted on a coloured background in a broad brush and fluid lines, and the space between the letters is filled with circles and abstract forms. The most significant aspect of this dish, however, is the sophisticated interlace at the centre of the dish with interweaving strapwork in the form of an eight-pointed star. This motif is the inspiration for the Aga Khan Museum logo.

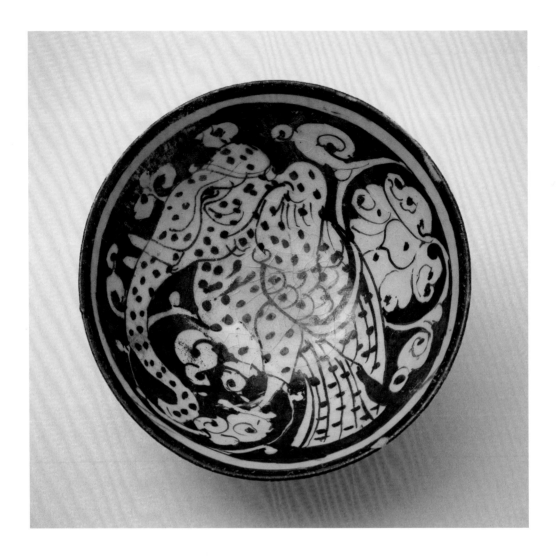

While the depiction of mythical creatures is common throughout Islamic civilizations, the elephant-bird image on this bowl is quite unique. This creature has the head of an elephant with a piercing look and flapping ears, and the body of a large bird with wings and talons perched on a vine scroll filling the bowl's background. While clearly mythical, it is possible that this depiction is inspired by oral narrations of a roster of mythical birds, including the *simorgh* of Attar's *Conference of the Birds* (twelfth century) and Ferdowsi's *Shah-Nameh* (994–1010), the roc (*rukh*) of *One Thousand and One Nights* (eighth to ninth centuries), and the bird carrying off an elephant from the Sanskrit *Mahabarata* (fourth century BCE) and *Ramayana* (fifth to fourth centuries BCE). It could have also been inspired by the now-extinct species of a giant flightless elephant bird native to Madagascar. This beautifully drawn image provides evidence of the craftsman's creative imagination and the folk traditions of the diverse cultures of the region.

Bowl

Iran, 13th century
Fritware, lustre-painted
Diameter 15.2 cm
AKM556

Bowl

Iran, early 13th century
Fritware, underglaze-painted
Diameter 21.9 cm, height 10 cm
AKM562

The development of a fritware ceramic (also known as stonepaste) in eleventh-century Iran revolutionized ceramic production, since it presented the opportunity to create a thinly potted white body that could easily be shaped and decorated. The new fritware ceramics could also be moulded into complex objects such as this conical bowl with its straight walls that are more suited to metalwork production. An early medieval recipe left by Abu'l-Qasem Kashani, a member of a family of potters, informs us that stonepaste is made out of ten parts ground quartz, one part ground glass, and one part fine white clay. The white body of this bowl is a perfect background for the combination of black-painted decoration and transparent turquoise glaze. The undulating stems of the water-weed motif on the sides of the bowl surround a school of fish painted in a thin brush, allowing for finer lines and elaborate flourishes.

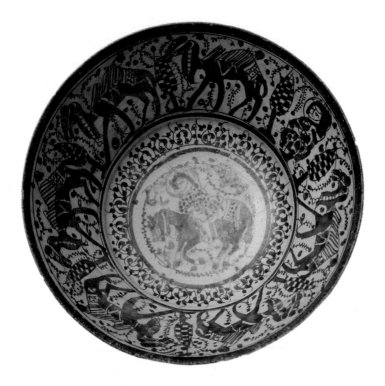

The mounted horseman—whether prince, hero, or warrior—remains one of the most common visual motifs in works of Islamic art. Here, the figure of a horseman is depicted at the centre of a conical bowl surrounded by a superb depiction of a merchant caravan. The sides of the bowl are decorated with six camels laden with bags led by an attendant. The artist has given the caravan a lively sense of animation, with the camels stepping forward to provide a feeling of motion that suits the circular nature of the vessel. The figures are rendered in metallic enamel paint that offers a golden lustrous sheen against the white background. Trees with a checkerboard pattern and branches with small leaves complete the landscape setting for the caravan. This style of fine depiction on thinly potted fritware ceramics was common in Kashan, Iran, in the late twelfth and early thirteenth centuries. There are many surviving examples, including a similar bowl in the Aga Khan Museum's collection, where the central mounted figure is encircled by horses instead of the camel caravan.

Bowl
Iran, early 13th century
Fritware, lustre-painted
Diameter 17 cm, height 8 cm
AKM557

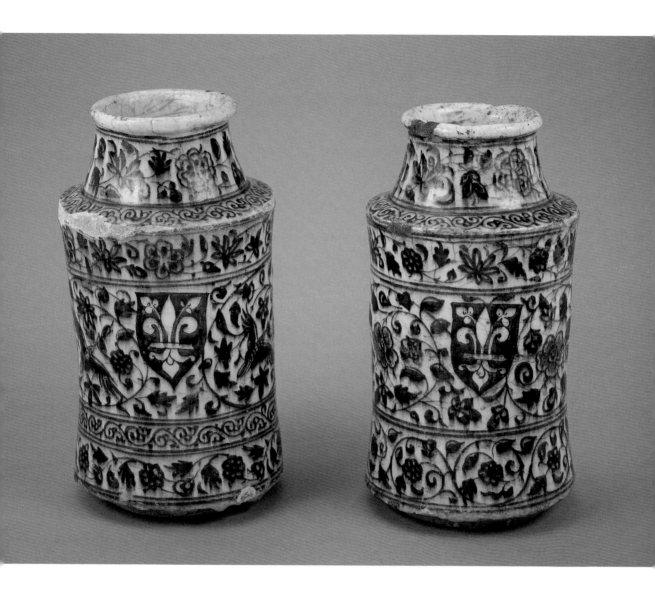

Pharmacy Jars (*Albarelli*)

Syria, 15th century

Fritware, underglaze-painted

AKM567: diameter 49.4 cm,
height 32 cm

AKM568: diameter 49.4 cm,
height 30.7 cm

Ceramic vessels were historically traded for their aesthetic value or as containers of valuable cargo. These two pharmaceutical jars, known as *albarelli*, are among a group of four magnificent examples from the Aga Khan Museum's collection, ranging in date between the thirteenth and fifteenth centuries and used for trading valuable pharmaceutical substances. Collectively, they highlight the active trade between the Mamluks (1250–1517) and Italian city-states such as Venice and Florence. This unique pair of *albarelli* is typical of the form, style, and design of ceramics made in Syria and Egypt in the fifteenth century, with the decorative motifs organized in clearly defined registers of intricate foliage painted in cobalt-blue under a clear glaze. The fleur-de-lys heraldic shield in the central band of each of the *albarelli* is most probably the coat of arms of Florence associated with the merchants who commissioned the precious cargo held in them or the city in which the lucrative trade was based (see also pages 15–16).

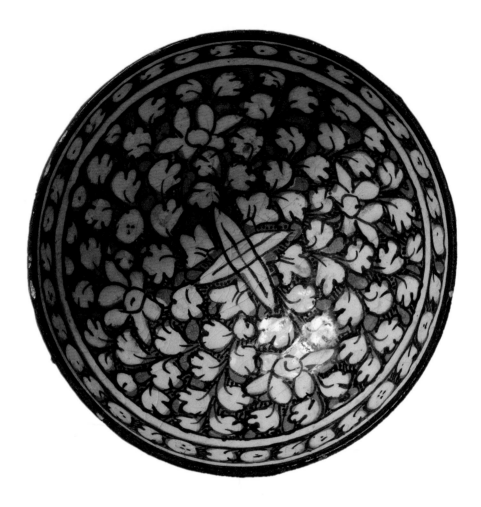

Textiles that were traded along the Silk Route were the most common way in which ideas and decorative motifs such as lotuses, dragons, and sphinxes were transferred between China and Iran. With the Mongol conquests of the thirteenth century, and the conversion of the Mongol Ilkhanid dynasty to Islam, Iranian potters began using these imported motifs in their designs. Here, the bowl is decorated with a mass of leaves surrounding lotus flowers. The bowl draws its influence from green-glazed stoneware known as celadon that was imported from China during the fourteenth century. The painted arcade panelling on the exterior of the bowl is a local rendition of the moulded form of the Chinese origin. This bowl, along with several other exquisite examples in the Aga Khan Museum's collection, is attributed to the city of Sultanabad in western Iran.

Bowl

Iran, early 14th century
Fritware, underglaze slip-painted
Diameter 17.8 cm, height 8.3 cm
AKM786

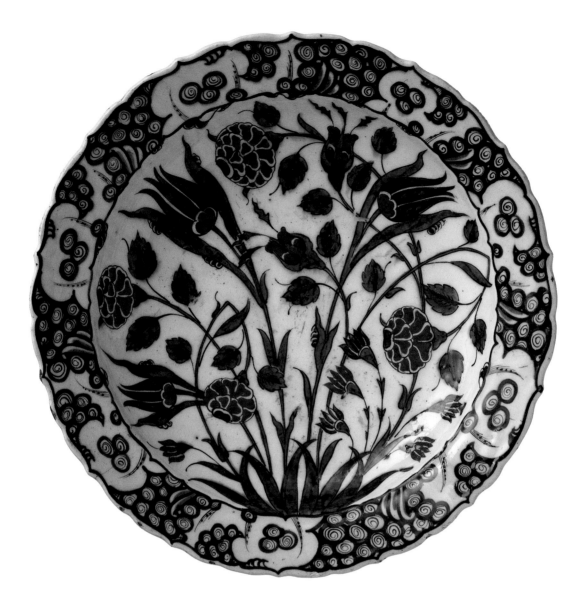

Dish

Iznik, Turkey, 1570–80
Fritware, underglaze slip-painted
Diameter 34.3 cm, height 7.4 cm
AKM687

During the first half of the sixteenth century, artists of the royal design atelier of the Ottoman court developed a new decorative style characterized by its bright colours and naturalistic depiction of flowers. The floral composition on this dish with its tulips, carnations, and roses in red and blue on a white background is typical of the production of the Ottoman imperial kilns in the city of Iznik. Similar patterns of floral designs were used on textiles, carpets, book illuminations, and tiles, including some splendid examples in the Aga Khan Museum's collection. The consistency of the Ottoman floral style helped establish a distinctive and singular visual brand for the Ottoman Empire and its arts. It is during this period that tulips caught Europe's attention when they were first introduced there by Ogier Ghiselin de Busbecq, the Austrian ambassador to the Ottoman court.

The multiple examples of sixteenth-century Chinese porcelain with Arabic inscriptions are testimony to the presence of an established Muslim community in China during that period, as well as the close and continuous contact between China and the Muslim world. This large dish was made in the porcelain kilns of the province of Jingdezhen in China for a Muslim patron, most probably a member of the close circle of Emperor Zhengde (reigned 1505–21) whose mark can be seen on the back of the dish. The word *taharat* ("purity") is inscribed in Arabic in the central medallion of the dish, implying that it was meant for use in ablution, a basic requirement of Muslim prayer. The Chinese-style floral meander on the rim of the dish and its back frames several inscriptions that further evoke the concept of ritual purity and specifically mention ablution (*al-wudu'*).

Ablution Basin

Jingdezhen, China, 1506–21
Porcelain, underglaze-painted
Diameter 41.8 cm, height 7.5 cm
AKM722

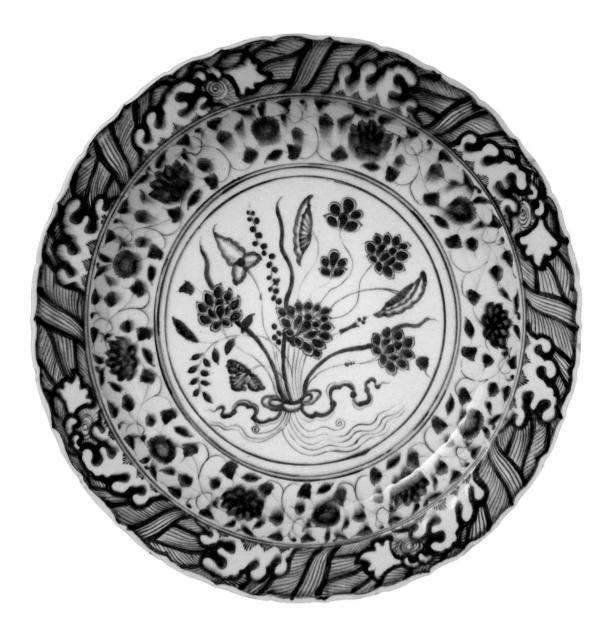

Dish

Iran, 17th century

Fritware, underglaze-painted

Diameter 46.6 cm

AKM588

The bouquet of blossoming lotus stems tied with a cloud-band ribbon at the centre of this large dish, the floral spray that surrounds it, and the wave pattern on its foliated rim are faithful copies of fifteenth-century motifs popular on Chinese porcelain in the Ming dynasty (1368–1644) almost two centuries before its manufacture. In the Safavid period (1501–1722), Chinese Ming porcelains were highly coveted for their beauty and translucency, and many were given as gifts to shrines, including the one in Ardabil dedicated to Sheykh Safi al-Din, after whom the Safavid dynasty was named. Iranian potters developed this style of blue-and-white ceramic employing a dense white fritware body and cobalt-blue painting under a transparent glaze to evoke these superb gifts.

Science and Learning

With the expansion of Muslim rule into the eastern Mediterranean regions and western Asia, the diverse Pre-Islamic science and learning traditions of the Greeks, Persians, Indians, and Chinese came into creative contact under the patronage of the ruling Muslim courts. A vast movement of translation, development, and innovation took place in the Abbasid courts of Baghdad between the eighth and tenth centuries where scientists and scholars from various religious and ethnic backgrounds worked together and achieved significant advances. Their creativity and innovations in the fields of science and philosophy were later transmitted to Europe and Asia and formed an important link in humanity's modern intellectual achievements.

Important pharmaceutical (AKM9) and medical (AKM510) manuscripts continued to be produced in multiple copies that were later translated into Latin in Toledo, Spain (AKM510), and Palermo, Sicily (AKM516), during the thirteenth century. The quality of the illustrations of some of these manuscripts (AKM83) suggests the high status in which they were held and perhaps the taste of their patrons.

The development of astronomical sciences (AKM266) and the increase in the precision of astronomical instruments were part of a traditional approach to practical science that evolved in close relationship with religious institutions of learning. The predominant function of astronomical knowledge in Muslim civilizations, however, was determining the direction of prayer (the *qibla*) and establishing prayer times. Scientific instruments such as astrolabes (AKM611) reflect the close relationship among the continuous discoveries in geography, descriptive geometry, and decorative styles.

Detail of *Tashrih-e Mansuri* (Anatomy by Mansur) (see page 80)
Mansur ibn Ilyas
Iran, mid-17th century
Ink and opaque watercolour on paper
Folio: 28.8 × 19.5 cm
AKM525

Written within fifteen years of the death of its author, this manuscript is one of the earliest surviving copies of volume five of the *Qanun [fi'l-tibb]* (Canon [of Medicine]) by the Persian scholar Ibn Sina or Avicenna (died 1037), as he is known in the West. Ibn Sina wrote a five-volume encyclopedia that brought together the Greco-Roman medical knowledge of Aristotle (died 322 BCE) and Galen (died circa 216 CE) with the advances in Chinese medicine of his time. Avicenna's *Qanun* was translated into Latin in Toledo, Spain, in the thirteenth century. It then became the most influential medical encyclopedia and was taught in European universities well into the eighteenth century. The Aga Khan Museum's collection also contains volume four of this rare copy of the encyclopedia (see also pages 12–13).

Qanun [Fi'l-Tibb] (Canon [of Medicine]), Volume 5

Ibn Sina (d. 1037)
Iran or Iraq, 1052
Opaque watercolour and ink on paper
Folio: 21.2 × 16.4 cm
AKM510

Al-Khashkhash (The Poppy)

Folio from a dispersed *Khawass Al-Ashjar* (*De Materia Medica*)
Iraq, 13th century
Opaque watercolour and ink on paper
29.8 × 20.5 cm
AKM9

This illustration of a poppy plant is part of a pharmaceutical tradition that identifies plants and herbs and explores their medicinal qualities. It is based on a treatise known as *De Materia Medica*, written in the first century by the Greek physician and botanist Dioscorides (died circa 90 CE) and translated into Arabic in Baghdad during the ninth century. In this folio, Dioscorides identifies three varieties of poppy seed, two of which are wild species and one that is cultivated (*thylacitis*) for its general health-inducing benefits. The treatise suggests baking the poppy seeds with bread or mixing them with honey, two practices still common today. Because the main function of this painting is scientific illustration, the watercolour depicts the root, stems, leaves, flowers, and pods of the poppy plant simultaneously.

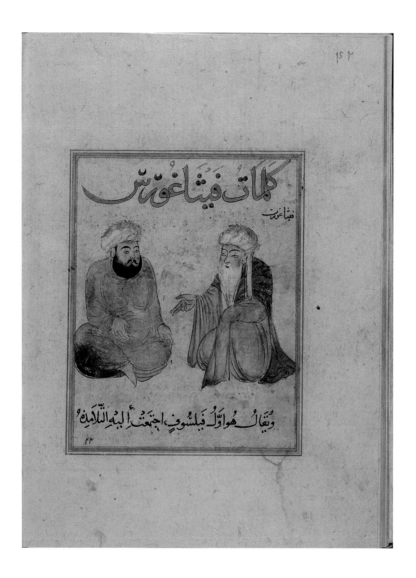

This image represents the didactic interaction between master and disciple or teacher and student as a traditional mode of transmission of knowledge and learning. In this manuscript, various images of the putative sources of Islamic philosophy are placed in direct contact with students whose questions result in the Greek philosophers' wise sayings. The teacher, in this case the Greek philosopher Pythagoras (died circa 495), is depicted as a turbaned older man talking possibly to a student. The anonymous author of this manuscript continues this didactic practice by passing its content on to the reader who becomes a participant in a venerable humanistic chain of knowledge.

Sayings of Pythagoras
Folio 21v from *Al-Kalimah Al-Ruhaniyah wa Al-Hikmah Al-Yunaniyah* (The Spiritual Word and the Greek Philosophy)
Iraq or Syria, 13th–14th centuries
Opaque watercolour, ink, and gold on paper
Folio: 20.6 × 15 cm
AKM283

Shiqraq (Green Magpie)

Folio from a dispersed *Manafi'
al-Hayawan* (The Usefulness of
Animals)
Ibn Bakhtishu (d. 1058)
Iran or Iraq, ca. 1300
Opaque watercolour, ink, and
gold on paper
25.7 × 20.5 cm
AKM83

The eleventh-century Persian physician Ibn Bakhtishu (died 1058) wrote the bestiary
Manafi' al-Hayawan (The Usefulness of Animals) following the Aristotelian tradition that
lists and describes animal species while highlighting their benefits. This folio is from a dis-
persed late thirteenth-century Persian copy of Ibn Bakhtishu's Arabic text. Other folios from
the same manuscript are now in major museum collections, including that of The Metro-
politan Museum of Art in New York. The painting style seen in this folio also brings together
various artistic traditions. By the end of the thirteenth century, book painting under the
Ilkhanids (1256–1353) demonstrated strong influences of Chinese-inspired elements seen
here in the depiction of twisted trees and the introduction of foreign plant species, includ-
ing the lotus. One of the benefits mentioned for the magpie (*shiqraq*) shown here is that
boiling its droppings in fat is a good treatment for darkening grey hair.

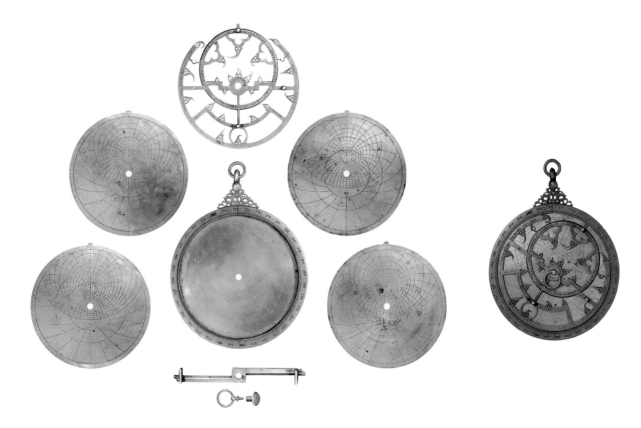

Centuries of Muslim rule in Spain (al-Andalus) saw the scientific knowledge inherited from Hellenistic and Indian traditions expanded by Muslim scientists and augmented by Christian and Jewish counterparts working together to translate and transmit this knowledge to Europe. This astrolabe was probably made in Toledo, Spain, then a major centre of scientific translation. The inscriptions on the astrolabe bear the names of constellations in both Arabic and Latin, with additional inscriptions in Arabic and Hebrew. The plates inside the astrolabe include projections for different geographical latitudes and represent different phases of use, confirming that the practical life of this astrolabe extended beyond the place and time of its initial manufacture. The predominant function of the astrolabe in Muslim civilizations was to determine the direction of prayer toward Mecca (the *qibla*) and to establish the times of prayer. This is usually achieved by using a plate with the precise celestial projections for Mecca on one of the plates inside the astrolabe's body, as indeed is the case for this unique astrolabe (see also pages 13–15).

Planispheric Astrolabe

Spain (Historic al-Andalus), 14th century
Bronze inlaid with silver
Diameter 13.5 cm
AKM611

The Constellations Andromeda and Pisces

Folio from a dispersed *Kitab Suwar al-Kawakib* (Images of the Fixed Stars)
'Abd al-Rahman al-Sufi (d. 986)
Iran, ca.1450
Opaque watercolour, ink, gold, and silver on paper
21.3 × 14.7 cm
AKM43

The lady in this saffron-coloured robe and crown-like helmet is a personification of the constellation Andromeda, which was identified by the second-century CE astronomer Ptolemy and continues to be considered a major constellation. With the translation of Ptolemy's *Almagest* in the court of the ninth-century Caliph al-Ma'mun in Baghdad, astronomers working under the patronage of the Muslim rulers in modern-day Iraq and Iran adopted the Greco-Roman astronomical knowledge and expanded on it from the indigenous Arab (*Anwa'*) and Indian astronomical traditions, in this illustration combining Andromeda with Pisces. The most prominent example of this tradition is Images of the Fixed Stars written by the Iranian astronomer 'Abd al-Rahman al-Sufi (died 986), which contained two representations of each constellation, one looking up at the constellation from Earth and the other looking down on it from above. Al-Sufi's work continued to be in broad circulation, and various copies exist in major museum collections.

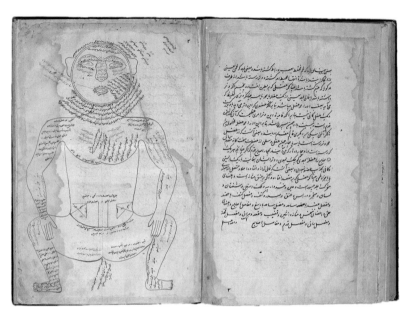

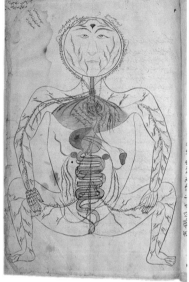

This anatomical manuscript was originally written in the fourteenth century by Mansur ibn Ilyas for his patron, the ruler of Fars in Iran. The seventeenth-century copy seen here has five full-page anatomical illustrations of various systems of the body, including the nervous system, skeleton, muscles, veins, and arteries. The anatomical knowledge portrayed in these paintings illustrates the Greco-Roman inheritance and its expansion under Muslim scientists and physicians.

Tashrih-e Mansuri
(Anatomy by Mansur)

Mansur ibn Ilyas
Iran, mid-17th century
Ink and opaque watercolour on paper
Folio: 28.8 × 19.5 cm
AKM525

The Constellation Auriga

Folio 48v–49r from a *Kitab Suwar
al-Kawakib al-Thabita* (Images of
the Fixed Stars)

'Abd al-Rahman al-Sufi (d. 986)

Isfahan, Iran, 1640s–1650s

Ink, opaque watercolour, and
gold on paper

Folio: 31.4 × 18.3 cm

AKM266

Although 'Abd al-Rahman al-Sufi's Images of the Fixed Stars was originally designed to
depict accurate longitudes for the constellations for the year 964, it continued to be cop-
ied for centuries after that. Considering that the main focus of the treatise is the astro-
nomical description and depiction of constellations, the representations in this manuscript,
including that of Auriga (the charioteer) seen here, faithfully follow the painting style of
seventeenth-century Iran. The thick, connected eyebrows of Auriga, the round cheeks,
small red mouth, and feathery hair, as well as the magnificent attention to the folds of the
figure's turban and knotted sash, are typical of the elegant courtiers depicted by a school
of painters that painted in the style of Iranian artist Reza-e 'Abbasi (died 1635).

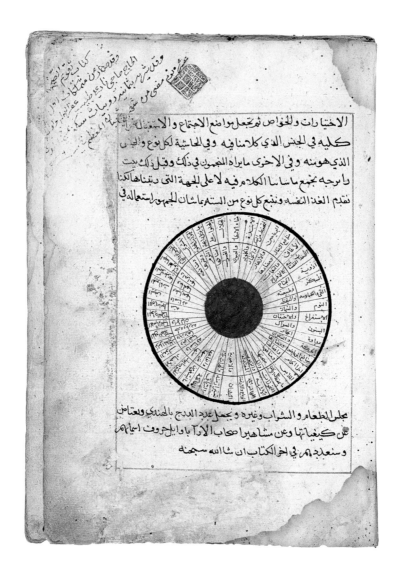

According to Ibn Butlan's *Taqwim al-Sihhah*, the maintenance of good health is dependent on six elements: the quality of air; healthy eating and drinking habits; exercise and rest; sleep; the balance of the humours; and the moderation of joy, anger, fear, and distress. While the theory of humours inherited by Muslim scientists from the Greek physician Hippocrates (died 370 BCE) was discredited by medical discoveries in the nineteenth century, Ibn Butlan's reasoning for health and hygiene based on a moderate lifestyle still resonates today. His treatise includes various tables that list types of habits, environments, drinks, and foodstuffs and links them to physiological effects on the body. *Taqwim al-Sihhah* was translated into Latin in Sicily in 1266 under the title *Tacuinum Sanitatis* and from there became popular in Europe.

Taqwim al-Sihhah bi'l-Asbab al-Sitta (Maintenance of Health Through Six Methods)
Ibn Butlan (d. 1066)
Iraq or Syria, 1344
Ink, opaque watercolour, and gold on paper
Folio: 30.1 × 20.5 cm
AKM516

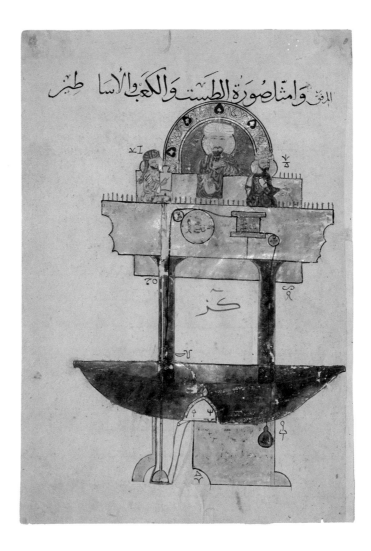

A Blood-Measuring Device

Kitab al-Hiyal al-naficah (The Book of Knowledge of Ingenious Mechanical Devices)

Al-Jazari (d. 1206)

Cairo, Egypt, 1354

Opaque watercolour, ink, gold, and silver on paper

27.3 × 39.1 cm

AKM11

This painting comes from a popular treatise on mechanical devices and automata written in 1206 and copied continuously in the following centuries. Al-Jazari, the author of *Kitab al-Hiyal al-naficah* (The Book of Knowledge of Ingenious Mechanical Devices), included descriptions of more than a hundred devices in his treatise, one of which can be seen here. This fascinating device builds on two scientific ideas: bloodletting as a medical treatment and the use of simple machines to create complex automata. The treatment of various ailments through bloodletting was common until the nineteenth century, and it clearly did not need such a complex device. Here, the patient puts a cut finger into a hole in the basin and blood falls through channels into a lower chamber, displacing a float. The float is attached to one end of a rod that, on its other end, attaches to the pen in the hand of the scribe on the upper left. As the level of the blood in the basin rises, it pushes the float up, moving the scribe's pen and indicating marks on his writing board.

Metalwork

The substantial number of metalwork objects from the Islamic world surviving in museum collections reflects a rich variety of shapes and forms with increasingly complex decorative programs and distinctive styles. The examples from the Aga Khan Museum collection presented here are chosen for their artistic value as well as for the questions they raise and the insights they provide on the metalwork industry and the Muslim societies within which these objects were produced.

Most of the objects presented here are made of variations of brass or bronze alloys, and only scientific analysis can confirm their exact chemical compositions. When these objects were inlaid with silver (AKM610) or gold (AKM609) or worked in repoussé (AKM884), they became objects of considerable beauty, and probably significant value. Another important material for metalworking was crucible steel, which was used for weapons, grilles, screens, and decorative plates (AKM616 and AKM679). Gold and silver were also employed to create objects for the court and for wealthy patrons, but those were regularly melted down and the metal repurposed, especially for minting coins. The most common form in which they survive is gold jewellery (AKM618, see page 116).

Metalwork objects had utilitarian purposes and served the everyday requirements of their owners (AKM726). Yet a few also had highly symbolic roles (AKM612 and AKM679). In all cases, surviving objects from the tenth century onward display a range of creative solutions in decorating metalwork and turning simple objects into works of art (AKM602).

Detail of
Candlestick
(see page 87)
Eastern Iran,
12th century
Embossed and
repoussé bronze
Diameter 46.5 cm,
height 35 cm
AKM884

The use of incense in the pre-modern period was believed to have health benefits. Through fumigation and vaporization, scents produced by burning aloe wood ('ud), frankincense, or ambergris were believed to expel and neutralize spirits and the illnesses they brought. Incense burners were also appreciated for the pleasant smell they generated. Although metalwork incense burners were made in a variety of shapes, including some birds, this cockerel-shaped incense burner with its magnificent tail and high crest is quite unique. The body of the bird is decorated with pierced interlace that allows the perfumed smoke to escape from the interior receptacle.

Incense Burner

Eastern Iran, 11th century
Copper inlaid bronze
28 × 28 cm
AKM602

Candlestick

Eastern Iran, 12th century

Embossed and repoussé bronze

Diameter 46.5 cm, height 35 cm

AKM884

This candlestick is one of a group of related candlesticks in major museum collections that were made out of hammered brass in the late twelfth or early thirteenth centuries in Khorasan (present-day northeast Iran and Afghanistan). Although the candlesticks have variations in size and decorative details, they all have a wide band of hexagonal bosses flanked by repoussé animal friezes on the top and bottom, sometimes extending into the candlestick's shoulder. The same style of low-relief sculptural lions protruding from a brass object is known from a ewer now in the National Museum in Tbilisi, Georgia, with an inscription linking it to eastern Iran and present-day Afghanistan.

This exceptionally beautiful basin is covered with an overall engraved decoration that brings together figural images, calligraphic compositions, and complex geometric patterns over a bed of floral scrolls. The upper band shows a style of interlaced and animated script that is predominantly used on metalwork. All the uprights are interlaced midway, most ending with a human head in a style that made its early appearance in eastern Iran during the eleventh century. The bottom row has representations of the twelve signs of the zodiac, also typical of metalwork from Khorasan. This bowl demonstrates how some metalworking techniques, like high-tin bronze (known as bell metal), and styles such as human-headed calligraphy, moved from their places of origin during the thirteenth century through the migration of artists and the exchange of objects.

Basin

Probably Iran, 13th century
Cast and engraved white bronze
Diameter 55 cm, height 25 cm
AKM607

Pen Box

Western Iran, late 13th century
Brass inlaid with gold and silver
Length 19.4 cm, width 4.5 cm
AKM609

Historians of the thirteenth and fourteenth centuries considered pen boxes and inkwells as part of the insignia of high-ranking government officials. They are also associated with men of knowledge and wisdom in poetry and in painted manuscripts. It is no wonder then that the Aga Khan Museum pen box, seen here, is so intricately and richly decorated. The overall design is outlined with silver wire hammered into the brass box, forming discreet areas mostly filled with floral and geometric silver inlay. As the most visible part of the pen box, the lid is decorated with larger pieces of silver in three elaborate roundels, with intricate rosettes and an inscription inlaid in gold running between them.

This striking brass bowl is both a feast to the eye and a window into the world of the Mamluks, who ruled Syria and Egypt between 1250 and 1517. The wide band of silver inlay carries a long inscription with the names and titles of a high-ranking official of the Mamluk sultan al-Malik al-Nasir Muhammad (died 1341). Here, the inscription in a bold *thuluth* script is the main decorative element, superseding the small figurative roundel in position and prominence. By the 1320s, the rhythmic tenor of letter uprights in calligraphic compositions became the main feature of Mamluk art. Inscriptions on Mamluk art, including metalwork, reflect the dynasty's concerns with power and self-representation, where individual sultans and high officials perpetuated their memory for posterity by having their names and titles inscribed on buildings and objects.

Bowl
Egypt or Syria, 1293–1341
Brass inlaid with silver
Diameter 20 cm, height 9 cm
AKM610

Tray Stand

Egypt or Syria, first half of
the 14th century
Brass inlaid with silver
Diameter 18.5 cm,
height 19.5 cm
AKM726

In the pre-modern world where most architectural spaces were multifunctional, tray stands and trays transformed any room into a temporary place of dining and feasting. This magnificent stand is decorated with an elegant combination of calligraphy and floral motifs. The bold *thuluth* inscription with exaggerated uprights eulogizes the official whose name it carries. The floral arabesques are used here in two different ways, achieving the layered effect typical of Mamluk metalwork. A floral scroll forms the background motif to the monumental inscription, and flowers are also employed as a main decorative element in the roundels punctuating the calligraphic bands. In these roundels the main floral motif is the lotus flower, which saw a revival under the Mamluks through the closer political and trade relationships with the Mongol Ilkhanids (1256–1353).

This beautifully engraved beggar's bowl (*kashkul*) is a ceremonial object that would have had pride of place in a Sufi lodge (*khanqah*). *Kashkuls* were used by wandering mystics who renounced their worldly possessions and subsisted on collecting alms. The bowl's elongated form and its related symbolic function derived from the Pre-Islamic Iranian tradition's wine boat. The *nasta'liq* inscription below the rim contains allegorical Persian verses about the Prophet Muhammad, 'Ali, and the friends of God, generally referring to the Sufi mystics.

Beggar's Bowl (*Kashkul*)

Iran, late 16th century
Engraved brass
Length 61 cm
AKM612

Candlestick (*Sham'dan*)

Iran, ca. 1560
Engraved brass
Height 37.9 cm
AKM613

I remember one night as my eyes wouldn't close
I heard the butterfly tell the candle
I am stricken with love, if I burn it is but right
But you why do you weep, why burn yourself out?

The above verse from a poem by the famous Iranian poet Sa'di (died 1291–92) is commonly found on candlesticks (*sham'dans*) of the Safavid period (1501–1722), including the upper band of the Aga Khan Museum candlestick shown here. The symbolic comparison between the mystic lover seeking the Divine and the moth yearning for the flame finds a natural home decorating lighting devices. Also typical of candlesticks from the Safavid period is split-palmette design on a cross-hatched background, here in an overall pattern that seems to rise along the ridges of the body. The overall floral scroll is interrupted by a six-lobed cusped arch chevron, which seems hidden in the densely engraved foliage.

Openwork steel screens and doors are mentioned in the historical annals as special gifts that were given by rulers and powerful individuals to shrines, especially those of the twelve Shia imams and their descendants. Steel was first extensively used as an architectural decorative element in the tomb of the Ilkhanid ruler Oljeitu, built between 1307 and 1314 in Sultaniyya, Iran, and prior to that mostly employed in arms and armour. From that time onward, elaborate screens, doors, and grilles were added to shrines. This steel plaque, for example, would have been part of the open-work components of a shrine door or decorative frieze with the names of the Shia *imams*. The inscription *Fatima al-Zahra'* ("Fatima the Radiant"), the name of the Prophet's daughter and her epithet, is carved out in an elegant contrast between the solid lines of the magisterial *thuluth* script and the intricately carved floral spiral that forms its background.

Plaque

Iran, late 17th century
Pierced steel
22.7 × 12 × 1 cm
AKM616

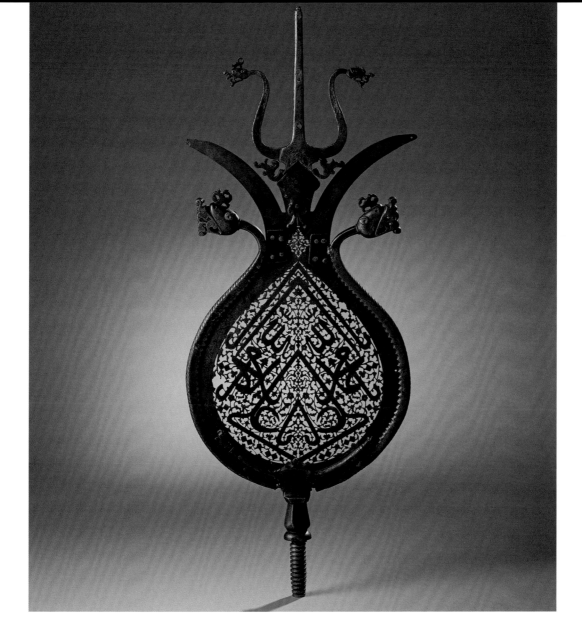

Processional Standard (*'Alam*)

Iran or India (Historic Hindustan),
16th century
Pierced steel
82 × 32.5 cm
AKM679

Processional standards (*'alams*) are used in Shia processions, particularly on the day of
'Ashura, the tenth day of the month of Muharram, to commemorate the martyrdom of the
Prophet Muhammad's grandson, al-Husayn, the son of 'Ali, in the seventh century in Kar-
bala', Iraq. In this openwork *'alam*, the form, decorative elements, and function are closely
intertwined. The bifurcated blades on the top of the pear-shaped body of this beautifully
carved *'alam* are a symbolic reference to the first Shia imam, 'Ali, the Prophet's son-in-law,
who is known by the epithet *dhu'l-fiqar* in reference to his bifurcated sword. 'Ali is also
referred to by name in the mirror-image inscription on the central field of this *'alam*: *ya
Allah ya Muhammad ya 'Ali*, calling upon God, Muhammad, and 'Ali for support. The sym-
metrical formation of the invocation *ya 'Ali* in the inscription is usually seen as depicting
the stylized face of a lion, another symbolic reference to the first imam.

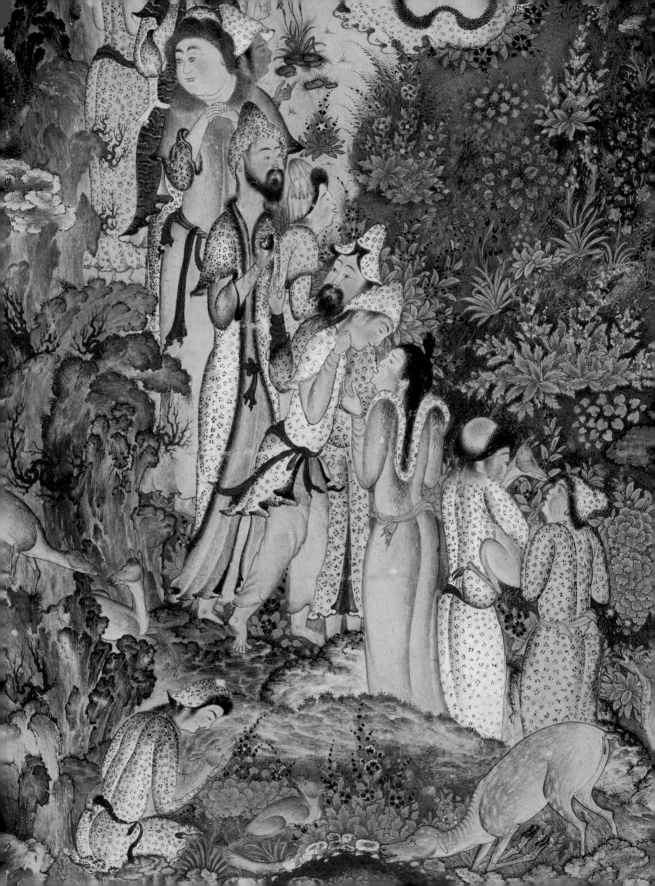

Painted Manuscripts

In Iran, Central Asia, and Moghul India, figural art found its predominant medium in painted manuscripts. Most paintings, as a result, were on paper and small in scale, hence the appellation "miniature." Yet the variety of topics and magnificent sense of detail defy their size and make this art truly unique. No detail was too small to include, from the patterns on textiles to the inscriptions on buildings and their decorative tiles.

In addition to the illustration of historical narratives and lyrical love poems with their traditional subjects of feasting, hunting, and fighting, artists produced single-page paintings that were later collected in albums containing paintings and calligraphic compositions collated together to the tastes and whims of their owners. The Safavids (1501–1722) and Moghuls (1526–1858) also developed an interest in portraiture (AKM124) that was heavily influenced by European prints as well as political and trade encounters.

Few artists are known by name before the sixteenth century, since most man-uscripts were products of a group of artists and single paintings were usually a collaborative work by various specialists, some designing and outlining while others painted faces, illuminated borders, or coloured the painting. By the sixteenth cen-tury, artists started producing single-page paintings for the open market and signing their names. Some artists' names were also recorded in contemporary sources, including the prefaces for albums that acted as concise narratives for the historical context for the development of Iranian painting.

The rising power of the Timurids (1370–1507) in Iran and Central Asia brought with it scholars and artists who were taken to Samarqand and became responsible for a new beginning to manuscript painting. After the death of Timur (also known as Tamerlane) in 1405, regional centres of patronage were established in other cities, including Herat, Shiraz, Tabriz, and Baghdad, each with its subtle stylistic variations. This painting style is represented in a battle scene (AKM92), where space and depth are created through raising the horizon line and placing figures and landscape in the foreground. In the last part of the sixteenth century, painters in Herat, including Behzad (circa 1450–1535), started developing their own styles and depicting new topics with expressive narratives such as his *Portrait of Hatefi the Poet* (AKM160).

Detail of *The Court of Keyomars* (see pages 102–03) Folio 20v from a *Shah-Nameh* (Book of Kings) produced for Shah Tahmasp I Painting by Soltan Mohammad Tabriz, Iran, ca. 1522 Opaque watercolour, ink, gold, and silver on paper 47 × 32 cm AKM165

Behzad continued his work under the Safavids and became head of the royal atelier in Tabriz, Iran, in 1522.

When the Safavids took control of Iran in the early sixteenth century, they inherited painting workshops and styles that were characterized by brilliant colours, lush vegetation, elaborate architectural compositions, and fantastical rock formations. *The Court of Keyomars* (AKM165) from the now-dispersed *Shah-Nameh* commissioned about 1525–35 by Shah Tahmasp I in Tabriz is perhaps the most celebrated example of the Safavid style with its exceptional quality of painting and composition. The Safavid artists' elaborate use of architecture to create a complex sequence of events within the picture—indicating inside/outside, before/after, et cetera—and their great attention to detail in depicting architectural decoration are at their most sumptuous in *Sindukht Brings Gifts to the Court of Sam* (AKM496).

Single drawings and paintings independent of a narrative text began appearing toward the end of the fifteenth century. As a result of the loosening grip of the conventional copying of set paintings that accompanied the illustration of literary texts and the rise of album collections, a new style of painting based on direct observation and lyrical imagination developed in Iran, Central Asia, and India. A remarkable example of this individual style is *A Resting Lion* (AKM111) by the prolific artist Mo'in Mosavvir (active circa 1630–97).

The Moghul dynasty, which ruled parts of India and Pakistan for more than three centuries, also followed Timurid examples in its patronage of the arts of the book. Moghul painting, however, combined Timurid artistic heritage with local Indian traditions and the influence of European prints. When the Moghul emperor Homayun (reigned 1530–40 and 1555–56) returned to India after a period of exile in the Safavid court, he brought back with him artists and tastes that infused Moghul art with a fresh wave of Iranian painting influence. Under Akbar the Great, who reigned from 1556 to 1605, Iranian painters along with Hindu and Muslim artists worked to establish magnificent works of art such as the paintings of the *Akhlaq-e Nasiri* (Ethics of Nasir) (AKM288). The Moghuls were specifically interested in naturalism and were avid patrons of animal and botanical studies. This interest varied from individual studies to the sumptuous floral borders surrounding Moghul paintings and calligraphic compositions.

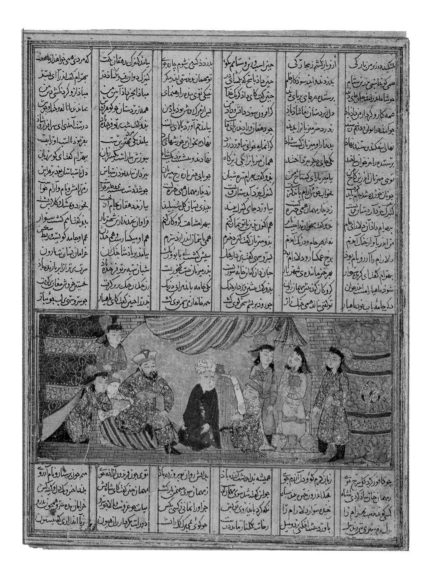

Bahram Gur at the House of Mahyar the Jeweller

Folio from a dispersed *Shah-Nameh* (Book of Kings)

Iran or Iraq, ca. 1300

Opaque watercolour, ink, and gold on paper

24 × 19.2 cm

AKM16

Bahram Gur at the House of Mahyar the Jeweller is a folio from one of the earliest surviving illustrated manuscripts of the *Shah-Nameh* (Book of Kings), the Iranian epic poem. The painting is placed in a rectangular frame occupying the full width of the six-column text of the epic. All the figures are in a row at the lower edge of the work, thus rendering the painting flat and two-dimensional. The lack of depth, however, is compensated by the lavish details of the work. In the story of the charming Prince Bahram Gur and Arzu, the beautiful daughter of Mahyar the jeweller, the sumptuously dressed group is being entertained in a house decorated with luxurious textiles. The richness and variety of textile types and patterns and the opulence of the golden shades of the painting reflect the importance of gold as a symbol of wealth and a store of value. This came at a time of prosperity in which the peace under the Ilkhanids (1256–1353) created a fertile ground for trade in gold-embroidered brocade textiles along the Silk Route.

The cascade of arrows hurtling back and forth between the two warring parties in this painting is symbolic of one of the recurring themes of the *Shah-Nameh*: the war between the Iranians and the Turanians, their Central Asian opponents. Advancing from the right is an Iranian army led by the mythical warrior Rostam on his loyal blue-armoured horse Rakhsh. As always, Rostam is identified by his tiger-skin clothes and by his prominent position in the painting. Not only is he larger in size than all the other characters but he alone has the courage to lead into battle on the open field. Rostam's valour and forward movement are contrasted on the left by the reticence of the Turanian army and the fall of their leader, Ashkabus, pierced by Rostam's flying arrow. By raising the horizon line to the top of the painting, the artist managed to create a large battle scene in the confined space of the paper.

Rostam Shooting the Turanian Hero Ashkabus
Folio from a dispersed *Shah-Nameh* (Book of Kings) produced for Sultan 'Ali Mirza
Lahijan, Iran, 1494
Opaque watercolour, ink, and gold on paper
23.3 × 15.2 cm
AKM92

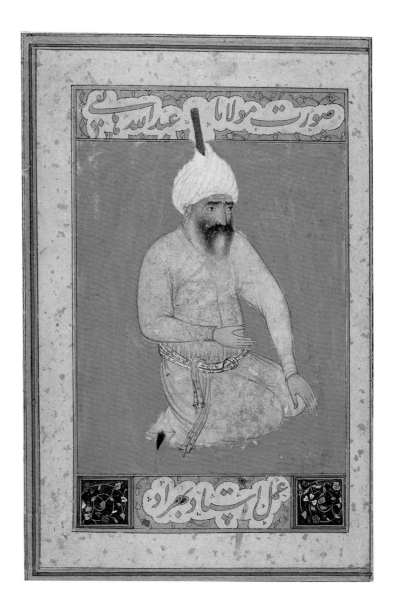

Portrait of Hatefi the Poet

Folio from a 1544–45 album assembled
for Bahram Mirza
Attributed to Behzad
Herat, Afghanistan (Historic Iran),
ca. 1511
Opaque watercolour, ink, and
gold on paper
11.8 × 7.8 cm
AKM160

The painter Behzad, whose work we see here, was celebrated as one of the most
renowned painters in Herat and Tabriz in Historic Iran during the late fifteenth and early
sixteenth centuries. By that time, Behzad was responsible for some of the most magnificent
Iranian paintings, two of which are in the Aga Khan Museum's collection. Behzad's painting
style is characterized by remarkable fine details and natural gestures that project an expres-
sive narrative and intense individuality of the painted subject. Here the Iranian poet Hatefi
(died 1520) is depicted with a greying beard and finely lined face, indicating his old age.
The purposefulness of his hand gesture, however, implies an ongoing conversation or per-
haps a poetry recital.

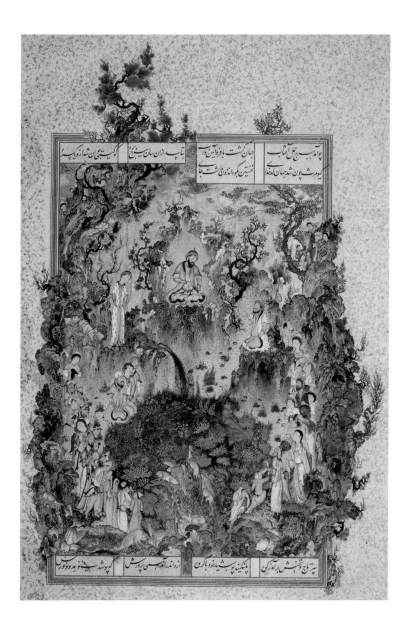

Described in the sixteenth century as a masterpiece and acknowledged to this day as one of the most important works of Iranian painting, *The Court of Keyomars* from the Shah Tahmasp I *Shah-Nameh* remains truly exceptional. The composition of the painting places the mythical King Keyomars at the centre of the narrative and at the apex of the oval composition. Surrounded by his son and grandson, the king pronounces news to all the creatures below him: human, animal, and the myriad of faces depicted in the rocks. The jewel-like intensity of the painting's colours and their variety and balance demonstrate the painter Soltan Moham-mad's exceptional mastery. The impeccable details and minute scale suggest the use of such fine brushes at times made of a single squirrel hair. No wonder it took Soltan Mohammad three years to paint this masterpiece for his royal patron Shah Tahmasp I.

The Court of Keyomars
Folio 20v from a *Shah-Nameh* (Book of Kings) produced for Shah Tahmasp I
Painting by Soltan Mohammad
Tabriz, Iran, ca. 1522
Opaque watercolour, ink, gold, and silver on paper
47 × 32 cm
AKM165

Of the various female heroes in the Iranian poetic tradition, none is more beguiling than Sindukht. Seen in this painting lavishing magnificent gifts and treasures on the mighty warrior Sam, Sindukht uses the old tradition of gift giving to invoke a social obligation that behooves the ruler to listen to her story and respond to her request. Her diplomacy convinces Sam to allow the marriage of his son, Zal, to her daughter, Rudabeh—a union that begets Rostam, the ultimate hero of the Iranian epic *Shah-Nameh*. This painting, which captures Sindukht's reception at Sam's palace, was made for Shah Tahmasp I and is from one of the greatest illustrated *Shah-Nameh* manuscripts. The scene is designed to capture the narrative on multiple levels and from different perspectives. The indoor sequence, on the left, reveals the palatial reception hall in the form of a raised central recess (*iwan*) that is richly decorated with glazed tiles, painted walls, and inscriptions. Meanwhile, outside the palace gate waits a caravan of attendants laden with gifts and accompanied by horses and mighty elephants.

Sindukht Brings Gifts to the Court of Sam

Folio 84v from a *Shah-Nameh* (Book of Kings) produced for Shah Tahmasp I
Tabriz, Iran, 1522–35
Opaque watercolour, ink, and gold on paper
46.5 × 31.2 cm
AKM496

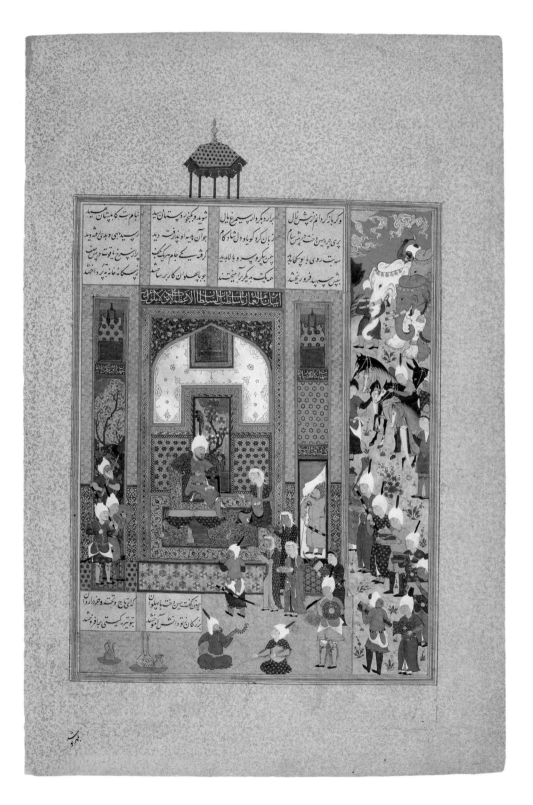

The school courtyard depicted here is one of seventeen paintings from a unique manu-
script produced in the court of the Moghul emperor Akbar the Great (reigned 1556–1605)
of the thirteenth-century philosophical work *Akhlaq-e Nasiri* (Ethics of Nasir) that was com-
posed by the Iranian philosopher and scientist Nasir al-Din Tusi. At the centre of the paint-
ing is a youth reading under the masterful eye of his teacher while other students study
independently in the building's courtyard. The scene is set in a red stone building, perhaps
a madrasa, with two large domes on either side of the courtyard. The text incorporated in
the painting is from the section of Tusi's treatise on the etiquette of learning and the cor-
rect behaviour of students, thus giving context to this scene. The disproportionate size of
the teacher and his elevated position on the carpeted platform are meant to convey his
authority and the importance of his role in the transmission of knowledge and learning.

*School Courtyard with
Boys Reading and Writing*

Folio 149v of the *Akhlaq-e Nasiri*
(Ethics of Nasir) by Tusi (d. 1274)
Northern India (Historic Hindustan),
1590–95
Opaque watercolour, ink, and
gold on paper
23.9 × 14.2 cm
AKM288

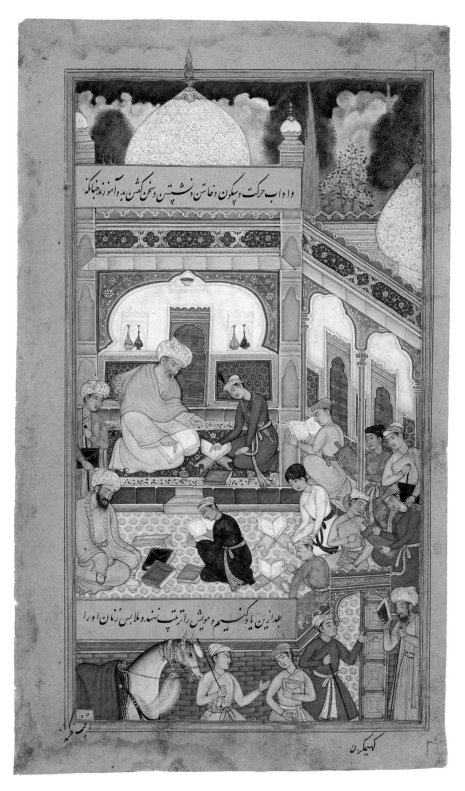

The Battle Between the Owls and Crows is an exquisite example of the illustrated man-
uscripts of animal fables that traverse cultures and histories with their familiar narratives
and unique paintings. The fable collection entitled *Anvar-e Soheyli* (Lights of Canopus) is a
twelfth-century translation of an Arabic version known as *Kalila wa Dimna*, itself translated
around 750 CE from a Syriac version derived from a Pahlavi edition of the Sanskrit collec-
tion of the fables called the *Panchatantra* (Five Principles), which was composed in India
in the third century BCE. Created in sixteenth-century Iran, this painting shows the owls'
vicious attack on the crows on top of a magnificent tree. The crows later orchestrate a witty
revenge against the owls using wisdom rather than force.

**The Battle Between the
Owls and Crows**

Folio 167r of the *Anvar-e
Soheyli* (Lights of Canopus)
Rendered into Persian by
Kashefi (d. 1504–05)
Attributed to Sadeqi Beg
Qazvin, Iran, 1593
Opaque watercolour, ink,
and gold on paper
30.3 × 20.6 cm
AKM289

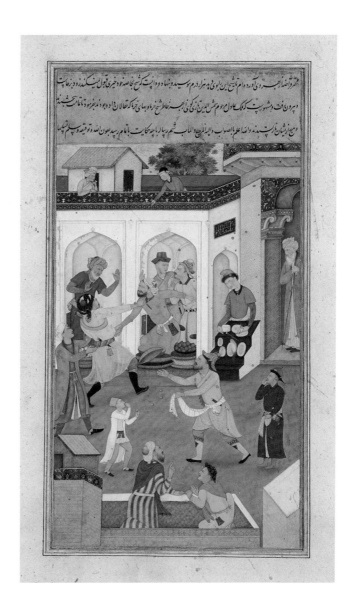

A Fight in the Bazaar

Folio 18v from a *Kulliyat* (Assembled
Works) of Sa'di (d. 1292)

Agra, India (Historic Hindustan),
ca. 1604

Opaque watercolour, ink, and
gold on paper

41.8 × 26.2 cm

AKM284

An agitated fruit seller is pulled into a fight by one of his customers while an incredulous
crowd gathers around them to intervene or just to observe. The scene is set in an open
space in front of shops housed beneath a whitewashed arcade near the city gate. The
arcade's pointed arches and diamond-shaped spandrels are precisely drawn. The artist
creates depth in the painting's composition through a clever placement of individuals and
the articulation of buildings. The fruit seller is at the focal point of a perspective formed
by the gesticulating onlookers, and further depth is provided by the three-dimensional
representation of the arcades. This approach to space and architecture is typical of early
Moghul painting and is beautifully represented by the twenty-three full-page paintings of
this manuscript in the Museum's collection.

This painting is a composite album page that was skillfully put together most probably before the death of Moghul Emperor Jahangir (reigned 1605–27). The upper portion of the folio has intricately illuminated sections dating to the fifteenth and late sixteenth centuries placed above two genealogical sections from the early seventeenth century. The central medallion with its elaborate border and jewel-like colours features Jahangir at the apex of his immediate family. The emperor is surrounded by portraits of his male progeny, some of whom are still young children. The bottom section of the album page has an earlier genealogy of Jahangir's Timurid ancestors.

Genealogical Chart of Jahangir
Signed by Dhanraj and anonymous artists
Agra, India (Historic Hindustan), 1610–23
Opaque watercolour, ink, and gold on paper
36.2 × 24.2 cm
AKM151

Shah Jahan, His Three Sons, and Asaf Khan

Probably Agra, India (Historic Hindustan), ca. 1628

Opaque watercolour, ink, and gold on paper

35.5 × 24.3 cm

AKM124

During the time of Emperor Jahangir, Moghul painting reflected his deep interest in realism, especially in portraiture and in the depiction of natural phenomena such as landscapes. This work, signed by the painter Manohar (active circa 1582–1624), depicts the Moghul emperor sitting on a royal dais with his three sons standing beside him. The figures are portrayed in the typical Moghul portraiture pose with the face in profile and the body in a frontal three-quarter position. The bejewelled and opulently dressed men in this painting, however, are not Jahangir and his sons but rather Jahangir's son, Shah Jahan (reigned 1628–57), and his grandsons. In their quest to legitimize their rule, Moghul emperors saw no harm in taking over pre-existing works of art, as if to place themselves in a more glorious historical past. In this case, new faces with physical features attributed to Shah Jahan, his sons, and his father-in-law, Asaf Khan, replace those of Jahangir, the original patron, and his sons.

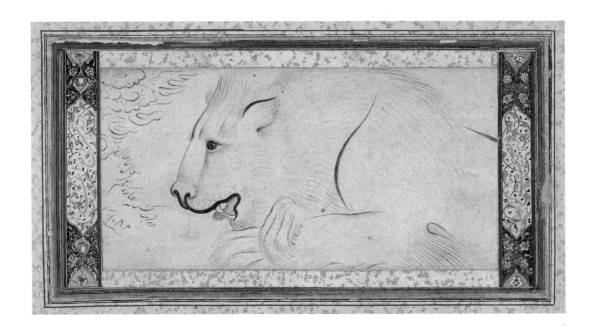

This lion demonstrates a confident style of drawing that evolved in Iran during the sixteenth century and became popular during the seventeenth century. A few fluid lines confidently outline the lion, marking its shoulder, back, mouth, and ear, while the rest of the body is drawn in shorter strokes with finer pens. The drawing is attributed to the Iranian artist Mo'in Mosavvir (active circa 1630–97), who signed two more known line drawings of similar animal topics in 1672 (see also pages 18–19).

A Resting Lion
Single-page drawing
Attributed to Mo'in Mosavvir
Isfahan, Iran, 1672
Ink, opaque watercolour,
and gold on paper
14.1 × 22.5 cm
AKM111

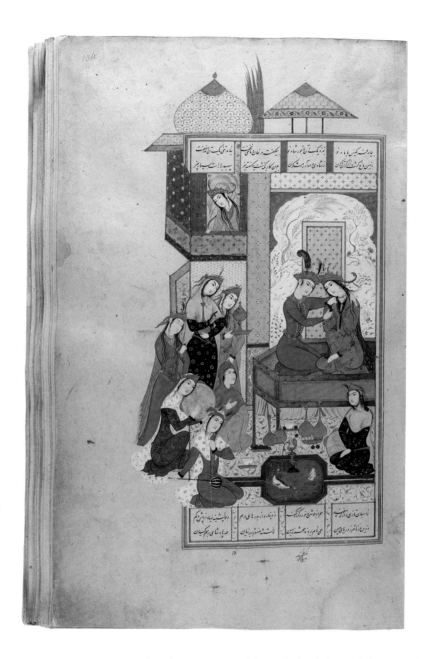

Siyavosh Marries Farangis
Folio 104r from the first volume
of a two-volume *Shah-Nameh*
(Book of Kings)
Painting by Mo'in Mosavvir
Isfahan, Iran, 1654
Opaque watercolour, ink, and
gold on paper
37.9 × 23.5 cm
AKM274

Love and marriage are two central themes in the *Shah-Nameh* that are used as tropes to explore ideas of valour and loyalty. Siyavosh, the son of Iranian King Kay Kavus, is celebrating his marriage to Farangis, the daughter of King Afrasiab, the Turanian enemy of Siyavosh's father. The handsome prince sits with his bride on a raised platform while celebrations take place around a water feature in the palace courtyard. Little does Siyavosh know that the jealousy of other warriors in the court will cause him to send his beloved Farangis to his family in Iran and then have to walk through a raging fire to prove his innocence and loyalty to the king.

Luxury Objects

Surrounding themselves with the most learned men their courts could attract and the most elegant, entertaining, and capable courtiers whose company they could muster, rulers and wealthy patrons also acquired wondrous and luxurious works of art that reinforced an image of status, wealth, and refinement. Artists and men of knowledge followed this insatiable source of patronage at times as part of a court atelier that became a hub of creativity, bringing together artists, aesthetic ideas, and manufacturing techniques from various parts of the world (AKM625 and AKM677).

In addition to commissioning remarkable architectural monuments, luxurious manuscripts (AKM165), and objects in textiles, gold, jade, and ivory, royal patrons were avid collectors of the arts. The Moghul emperor Shah Jahan (reigned 1628–58), for example, collected curiosities, Chinese porcelains (AKM966), manuscripts and calligraphic samples (AKM351), and paintings (AKM124).

High officials and wealthy merchants often copied the passion for luxury and grandeur reflected in the arts produced for court ateliers. The arts of the royal courts of al-Andalus (present-day southern Spain), for instance, are best known from magnificent architectural monuments such as the fourteenth-century Nasrid palace complex of the Alhambra. After the demise of the ruling dynasty, wealthy Christian patrons continued the use of the royal court's style of woodcarving with bone and mother-of-pearl inlay in geometric patterns and abstract plant motifs (AKM634). The beauty and exceptional workmanship of some works of art that have no inscriptions with names of royal patrons (AKM538 and AKM618) bear the hallmark of a discerning benefactor, perhaps not royal, yet eager to own and display a privileged appreciation of the arts.

Detail from
Compendium
(see page 122)
Iran, 19th century
Enamelled gold
Diameter 9 cm
AKM625

This beautifully made golden bead would have been part of a sumptuous necklace created in the eleventh century during the Fatimid dynasty, which ruled in North Africa, Egypt, and Syria between 909 and 1171. The openwork gold filigree with elaborate granulation is characteristic of the goldsmith technique of the period and is known in historical sources as *mushabbak*. The bead has a box construction in the form of two cones of decorative gold wire strips supporting single or paired S-shaped twisted and granulated wires. The overall impression is one of remarkable skill and lush design befitting the accounts of the Fatimids' great wealth. With their domain straddling the trade routes of Africa, the Mediterranean, and the Indian Ocean, the Fatimids were well-known as avid patrons of art and architecture.

Bead
Egypt or Syria, 11th century
Gold filigree
Length 7.2 cm, height 2.9 cm
AKM618

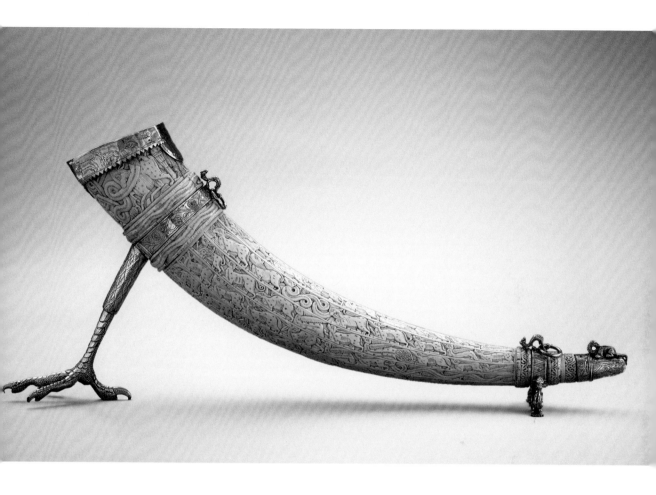

Ivory Horn (Oliphant)

Southern Italy, 11th–12th centuries
(mount: Great Britain,
early 17th century)
Carved ivory with silver mount
Length 64 cm, height 34 cm
AKM809

This rare carved ivory tusk is an exceptional example of the dissemination and exchange of visual culture across the eastern Mediterranean among the Fatimids (909–1171), the Byzantine Empire, and the Italian city-states. It is one of a few examples surviving in major museum collections that were carved in Sicily or southern Italy, with images derived from Fatimid court culture and iconographic style. Known as an oliphant, this tusk is decorated with a hunting scene with real and mythical animals running in file across its length. The first recorded use of the word *oliphant* is in the twelfth-century French epic *La Chanson de Roland* where the hero uses an oliphant as a sounding horn to warn Charlemagne's army against the Muslim attack during the eighth-century Battle of Roncesvalles. Oliphants are also known as hunting horns and indeed hunting and animals are the predominant decorative themes on surviving oliphants. The exquisite carved decoration on this oliphant, and the silver mounts that were added in the seventeenth century, suggest it may have also served a ceremonial role (see also pages 10–12).

Known to the world as the builder of the white-marble-clad Taj Mahal, Shah Jahan (reigned 1627–58) was an avid collector of the arts. Like Emperors Babur (reigned 1526–30) and Jahangir (reigned 1605–27) before him, he collected curiosities, Chinese porcelains, jade, and objects adorned with precious stones. He also accumulated antiques, especially those made for his Timurid (1370–1507) ancestors, including several jade objects produced for Ulugh Beg (reigned 1411–49), the Timurid ruler of Central Asia. The Aga Khan Museum's rare porcelain ewer, seen here, was made in the imperial kilns at Jingdezhen for the Yongle Emperor of China (reigned 1402–24). By the time it entered the court of Shah Jahan in 1643, it was already an antique created more than a century earlier. One wonders whether Shah Jahan acquired it directly from China or if it was part of the collection of objects he acquired in Central Asia along with the jade objects belonging to Ulugh Beg.

Ewer

China, 1403–24 (with Shah Jahan's dated cartouche, 1643)
Porcelain, glazed
Height 19.3 cm
AKM966

Robe

Iran or Central Asia,
13th–14th centuries

Silk and metal thread

Height 140 cm

AKM677

This rare silk robe with a fitted waist, flared skirt, and tiny-button closure is a remarkable example of luxury clothing under the Mongols who governed the area from China to Iran during most of the thirteenth and fourteenth centuries. The vast region under the control of the Mongols established relative peace and safety that facilitated the movement of raw materials, technical knowledge, visual motifs, and able craftsmen, resulting in revolutionary advances in the arts of the Mongol Ilkhans, who ruled Iran between 1256 and 1353 and adopted Islam in 1295. Sumptuous textiles woven from silk cloth wrapped with gold, like this robe, were made in various areas and traded into Europe where they became known as Tartar cloth or *panni tartarici*. The roundels on the Aga Khan Museum robe, however, are decorated with pseudo-writing that suggests it was made in Iran or Central Asia. This robe would have been worn under an open outer coat with short sleeves in order to better display the expensive and beautiful textile underneath. The robe's arms are extraordinarily long and would have been pushed up around the forearm, adding a layer of protection as well as emphasizing the abundance of gold woven silk available to its owner.

Geometric patterns and plant ornaments continued to be the most prominent decorative features of luxury items made by Muslim craftsmen, known as Mudéjar, who continued to live in Spain after the fall of al-Andalus in 1492. This remarkable walnut box was used to store writing paraphernalia, with an inner, lidded compartment for smaller writing implements. The intricate designs decorating the chest have typical sixteenth-century Mudéjar features, including bone and mother-of-pearl inlay and rosettes in the form of eight-pointed stars with petal-shape arms. The survival of a few examples in major museum collections demonstrates the importance given to luxurious inlaid scribal chests and the continuity of demand for Mudéjar art by the Christian patrons of sixteenth-century Spain.

Scribe's Chest

Spain, 15th–16th centuries
Wood inlaid with bone, metal,
wood, and mother-of-pearl
22 × 49 × 33 cm
AKM634

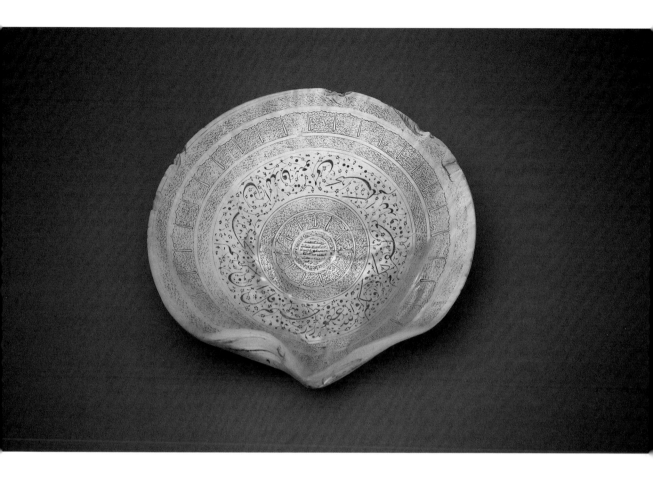

Shell with Inscriptions

India (Historic Hindustan),
18th century
Incised mother-of-pearl
Diameter 14.5 cm
AKM665

This palm-size, perfectly shaped mother-of-pearl shell displays an elegant design and an intriguing function. Its luminous surface is engraved with eight concentric rings containing verses from the Qur'an and religious supplications. The variety of the calligraphic styles and their layout make the design both dynamic and quite dignified. Although the intensity of the decorative program on the shell and the attention given to the minutest detail are unique, the shell may have been designed for a specific purpose that demonstrates how Muslims evoked the Qur'an in their everyday lives. The concave shape of the shell and some of its decorative motifs suggest that it may have been used as a drinking vessel. In line with the belief in the protective and therapeutic power of the Qur'an, some Muslims drank water that came into direct contact with Qur'anic verses in order to obtain blessings and protection. Could this have been the role of this singular shell?

This astronomical compendium was made in nineteenth-century Iran to reflect the
wealth and finesse of its owner. It contains miniature astronomical instruments in a small
gold-enamelled box that would have been hung from a chain or held in a pocket. In addi-
tion to a universal equinoctial dial and a compass, the compendium holds a depiction of
a horseman with a falcon, perhaps that of the owner. The box reflects the Qajar court's
(1779–1925) taste for personal luxury objects and interest in scientific knowledge and
trade with Europe.

Compendium

Iran, 19th century
Enamelled gold
Diameter 9 cm
AKM625

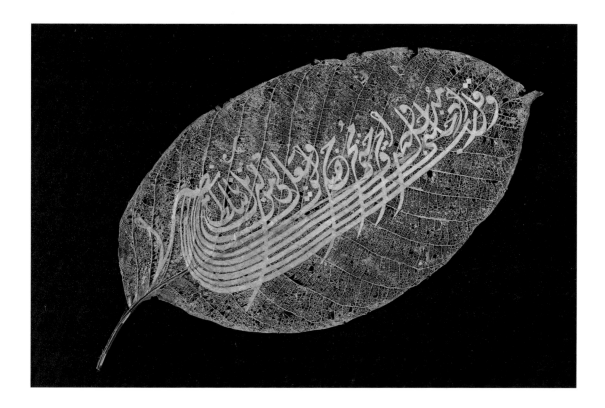

Leaf with Calligraphic Composition

Turkey, 19th century
Gold on chestnut leaf
13.5 × 28 cm
AKM538

The skill and artistic virtuosity required to create this exceptional decorative object reflect the importance given by Muslims to applying Qur'anic verses on a broad variety of objects as a constant reminder of their faith and its centrality to their lives. Here, a sweet chestnut leaf is inscribed with a Qur'anic verse from Surat al-Isra' ("The Night Journey," Q17:80), which reads: "And say, 'Lord grant me a good entrance and a goodly exit, and sustain me with Your power." The calligrapher composed the verse in the form of a boat with the letters forming passengers and oars, perhaps recalling the journey of life. To make this extraordinary leaf, the calligrapher wrote the inscription on the leaf and sealed the writing on both sides with a wax barrier. He then soaked the leaf in an alkaline solution just long enough to dissolve most of the vegetable matter, while leaving the skeleton and the inscription intact. Gold leaf was then applied to the leaf, adding shine, value, and a luxurious effect (see also page 19).

Drifting on the ocean from its native habitat on the Seychelles near the coast of southeast Africa all the way to the shores of India and Iran, the coco-de-mer nut (*Lodoicea maldivica*) acquired a mystical significance. Its voyage became symbolic of the journey of the Sufi mystic on the path leading to spiritual knowledge. This mystical connection may have led to the function of this remarkable object as a beggar's bowl (*kashkul*) carried by a Sufi *dervish* as a sign of renouncing all worldly possessions and subsisting on the generosity of humanity. The *kashkul* is fashioned from the shell of half of the nut, with carved inscriptions and supplications in Arabic and Persian. The upper band of inscription contains the Nad-e 'Ali, the devotional prayer to 'Ali. The rest of the prayer reads: "Help me with your hidden kindness, God is higher than the fire of your torture O ... with Your Mercy O You, most Merciful of all those who are merciful, God is my Lord, my aid comes from You O . . . "

Beggar's Bowl (*Kashkul*)

Iran, 18th century
Carved nutshell
Length 24 cm
AKM640

Pen Box

Iran, 1863–65

Papier mâché, paint, and varnish

Length 26.8 cm

AKM643

The art of painting on pasteboard or papier mâché under a lacquer varnish (lacquer painting) that decorates this extraordinary pen box was introduced to Iran through the extensive trade and diplomatic contact with China where the technique originated. Lacquer painting became a prominent technique to embellish the bindings of books and pen boxes under the Safavids (1501–1722) and the Qajars (1779–1925) in Iran. The painter of this box, Muhammad Isma'il, demonstrated his exceptional skill of minutely detailed painting by using an impressive repertoire of subjects. Individual cartouches all over the body of the box are adorned with representations of the Qajar ruler Nasir al-Din Shah (reigned 1848–96), legendary kings from the *Shah-Nameh*, portraits of famous Sufis, and depictions from the poems of Sa'di (died 1291) and Nezami (died 1209). One wonders if this pen box celebrates the art of writing or commemorates instead the painter whose signature and self-portrait decorate its interior.

Calligraphy and Illumination

Calligraphy, the art of beautiful writing, has a special status in many art traditions, but none more so than in the arts of the Islamic civilizations. Writing is intimately linked with the Qur'an, which Muslims believe to be the Word of God revealed to the Prophet Muhammad in the early seventh century, first orally and then compiled by his followers and written down. The sanctity of the written Word imbued calligraphy more generally with a symbolic status so that calligraphers were highly esteemed, elevating them to the most prominent position among all artists in Muslim cultures. There are more known names and surviving biographies of calligraphers than there are of any other artists.

With the spread of Islam from the Arabian Peninsula to North Africa and Spain in the west, and Iran, Turkey, Central Asia, South Asia, and Southeast Asia in the east, Arabic script came to be used for other languages, including Persian (Farsi), Chaghatai Turkish (AKM227), Ottoman Turkish, Urdu, Malay, and Swahili. While Arabic remained the main language for religious texts, the predominant literary and intellectual tongue was Persian, which was employed by the literary elite of the ruling courts throughout present-day Iran, Central Asia, Turkey, and South Asia.

In the section on Qur'ans in this book (see pages 42–57), calligraphic examples with angular Kufic and cursive scripts were used predominantly for copying the Qur'an. The collection highlights shown here, though, are mostly exceptional single-page literary compositions. Iranian calligraphers developed a new cursive, sloping script during the fourteenth century known as *nasta'liq* that was typically found in literary and poetic compositions. Calligraphy was applied by a variety of reed pens and at times cut from paper (*qat'*) to further demonstrate the virtuosity of the calligrapher (AKM227). The calligrapher's art was highly sought after and collected in albums (*moraqqa'*) with decorative borders in various techniques, including painting (AKM249) and marbling (AKM254).

Detail from
Page of Nasta'liq
Calligraphy
(see page 131)
Signed by Prince
Dara Shikoh
(d. 1659)
Burhanpur, India
(Historic Hindustan),
1631–32 (border
18th century)
Opaque water-
colour, ink, and
gold on paper
42.3 × 28.8 cm
AKM249

This exceptional composition is from a dispersed collection of poetry (*divan*) composed by the Timurid sultan Hosayn Bayqara, who ruled Herat in present-day Afghanistan from 1469 to 1506. Although Persian was the common literary and administrative language in Central Asia, the Timurids (1370–1507) maintained their native Turkic tongue, Chaghatai, in which these verses are written. Chaghatai became a prestigious literary language in which famous poets, including the founder of the Moghul dynasty, Babur (reigned 1526–30), and the poet-statesman Mir 'Ali Shir Nawa'i (died 1501), left remarkable works. The verses in this example were written in a *nasta'liq* script cut from paper in three different colours, then pasted onto the deep blue background before being set in a gold-speckled paper frame. The most famous practitioner of the cut-calligraphy technique (*qat'*) is Sheykh 'Abdollah of Herat, who signed several other folios from this beautiful manuscript. According to his contemporary Babur, however, the quality of Sultan Hosayn Bayqara's poetry in this *divan* is not good enough. Could this marvellous calligraphic presentation make up for that?

Découpé Calligraphic Example
From a dispersed *Divan* of Sultan
Hosayn Bayqara (d. 1506)
Herat, Afghanistan (Historic Iran),
ca. 1475
Opaque watercolour, ink,
and gold on paper
23.7 × 15.2 cm
AKM227

Page of *Nasta'liq* Calligraphy from a Royal Moghul Album

Signed by Mir 'Ali al-Soltani
Calligraphy: Iran, 1520; border:
India (Historic Hindustan), ca. 1640
Opaque watercolour, ink, and
gold on paper
36.9 × 25.2 cm
AKM351

Not only did the Moghul ruler Shah Jahan (reigned 1628–58) have a keen interest and discerning approach when acquiring Chinese porcelains (AKM966) and Iranian jades but he was also an avid collector of paintings and calligraphic specimens. A fine example of calligraphy is this Persian quatrain penned by the prolific poet-calligrapher Mir 'Ali al-Soltani (died 1544), who was famous for the diagonal format of his *nasta'liq* poetry. The calligrapher, who is also reported to have designed the lion format of the Nad-e 'Ali (AKM526), was extremely sought after by the Moghul sultans who would have mounted the prized calligraphic specimens in sumptuous albums (*moraqqa'*) and surrounded them with borders of painted floral decoration.

Shah Mahmud Neyshaburi (died circa 1564–65), whose signature is seen in the bottom left triangle of the text panel, was one of the most renowned calligraphers in the court of the Safavid shah Tahmasp I (reigned 1524–76). His masterful works for the shah, including a *Khamseh* of Nezami now in the British Library in London, and a unique *nasta'liq* Qur'an now at the Topkapı Palace Museum Library in Istanbul, earned him the epithets Shahi and Zarin Qalam (Golden Pen). Neyshaburi's calligraphic style is known for its elegant *nasta'liq*, which creates balanced compositions through the rhythmic elongation of horizontal strokes. The border of Neyshaburi's calligraphic panel is decorated with a blue-and-gold marbling effect known as *abri* (*ebru* in Turkish) used in Iran and Central Asia in the fifteenth century. Artists today still use the same method to achieve the elegant swirling effect of marbling by developing the desired pattern and colours in a water bath and then transferring them to paper.

Page of *Nasta'liq* Calligraphy

Signed by Shah Mahmud Neyshaburi
Mashhad, Iran, ca. 1540
Opaque watercolour, ink, and
gold on paper
26.7 × 16.7 cm
AKM254

Page of *Nasta'liq* Calligraphy

Signed by Prince Dara Shikoh (d. 1659)
Burhanpur, India (Historic Hindustan),
1631–32 (border 18th century)
Opaque watercolour, ink, and
gold on paper
42.3 × 28.8 cm
AKM249

The Moghuls (1526–1858) considered calligraphy to be one of the noblest arts that were fit for a prince, and many of the Moghul emperors were fine calligraphers. They also collected elegant calligraphic compositions and writing examples by renowned masters in lavishly decorated albums. This superb page was penned by the Moghul prince Dara Shikoh, Shah Jahan's eldest son, who was killed by his brother, Aurangzeb, in a power struggle in 1659. Dara Shikoh was known for his intellectual pursuits and his patronage of the arts. His personal collection of paintings and calligraphy included an exceptional album that he presented to his wife, Nadira Banu Begum, in the 1630s, now in the British Library. Dara Shikoh's calligraphic sample was later mounted in an eighteenth-century album where it was set in a floral border. This border reflects the Moghuls' avid interest in all natural phenomena and the close observation and depiction of animals and flowers as part of album borders or as intricately painted specimen studies.

My God, if the entire universe should be blown by wind
Let not the light of fortune be extinguished
And if the entire universe should become flooded with water
Let not the mark of the unfortunate be washed away!

The above Persian quatrain, written in a heavy *nasta'liq*, is typical of the hand of the pro-
lific Persian calligrapher Mir 'Ali of Herat (died 1544). Mir 'Ali's work was appreciated by
the Moghuls and collected and bound in superb albums (AKM351). Here, this page from
an album made for Shah Jahan (reigned 1628–58) uses an elegant collage of different
types of papers around the calligraphy, including two narrow bands with marbled paper
(AKM254). The paper collage with Mir 'Ali's quatrains at its centre was set in an exceptional
border of a natural landscape. The painter of the border, Dawlat Khan, has depicted a finely
illustrated group of deer, antelopes, and *nilgai* (blue bull) in a lush landscape with a rich
variety of tropical birds, all watched by a crouching cheetah in the bottom left of the border.
The precision with which the animals are drawn suggests that the artist drew upon manuals
that perhaps came into his possession through Western influences at the Moghul court.

Page of *Nasta'liq* Calligraphy
Signed by Mir 'Ali, ca. 1520
Opaque watercolour, ink, and
gold on paper
39.2 × 25.4 cm
AKM145

Devotional Calligraphic Composition

India (Historic Hindustan),
17th century
Opaque watercolour, ink,
and gold on paper
12 × 19.2 cm
AKM526

This splendid calligraphic lion is an example of zoomorphic writing where calligraphers blended the arts of writing and drawing by using words to form animal and human shapes. The choice of the lion here is quite pertinent since the Arabic text is a supplication to 'Ali, the Prophet Muhammad's cousin and son-in-law, who was the fourth caliph and first imam. Because of his courage and valour, 'Ali was known to Sunni and Shia Muslims by the epithet "The Lion of God." The prayer, known as Nad-e 'Ali, is typically used by Shia Muslims to seek 'Ali's help and support in times of stress and sorrow. What is interesting here is that the seventeenth-century calligrapher was so faithful in copying from an earlier model that he also replicated the signature of the original sixteenth-century calligrapher, most probably the famous Safavid calligrapher Mir 'Ali Haravi. That signature forms the hind leg of the lion in the original composition.

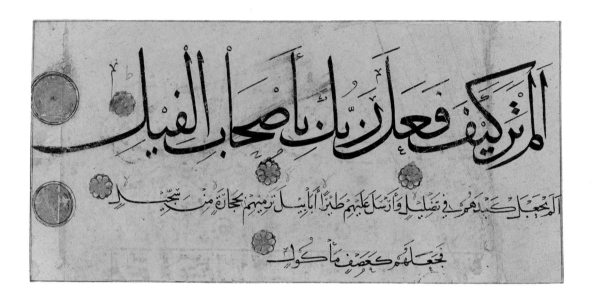

Treatises on calligraphy repeatedly warn the student that the only way to attain perfectly proportioned beautiful writing is by continuously copying and repeating a teacher's work. This master-to-pupil training process often produced various copies of a single text at different stages of development, several of which are now in major museum collections. This exceptional composition is an example of a calligraphic exercise, but the pupil here must have been quite advanced in his or her training since the text contains a full chapter of the Qur'an (Surat al-Fil 105:1–5) in two different scripts, as well as all the additional markers that characterize a finished work. While the first line is rendered in a larger-scale angular script with flattened curves known as *muhaqqaq*, the rest is in the simplest and most commonly used cursive script known as *naskh*. Typical of other calligraphic exercises under the Ottomans (1299–1923), this writing specimen would not have been meant for public display but rather it would have been collected in a calligrapher's *moraqqa'* or teaching album.

Page of Calligraphic Exercise

Turkey, 17th century
Ink and gold on paper
13.1 × 27.5 cm
AKM349

**Letter from Crown Prince
'Abbas Mirza to Napoleon I**

Tehran, Iran, 1808
Opaque watercolour, ink,
and gold on paper
120 × 58 cm
AKM251

Although the main purpose of this diplomatic letter was to seek French support against Russia, one-third of its length is filled with a decorative gold-illuminated heading. The magnificent heading was meant to express to its recipient, the French emperor Napoleon Bonaparte (reigned 1804–14), the importance of the sender, the crown prince 'Abbas Mirza, son of Qajar ruler Fath 'Ali Shah (reigned 1797–1834). The broad, empty margin on the right and the exaggerated distance between the written lines were also intended to convey a sense of prominence. Following a long Persian chancery tradition, the letter is written in a controlled *nasta'liq*, a cursive, sloping script that evolved in fourteenth-century Iran and was typically used for literary and poetic compositions (AKM227 and AKM145).

Accordion Album of Calligraphic Examples in *Shikasteh Nasta'liq*

Iran, 1800–50

Ink and gold on paper
with leather binding

29.2 × 19 cm

AKM360

This forty-eight-page album displays different calligraphic examples of the script known as *shikasteh* (also *shikasteh nasta'liq*). Developed predominantly to enable the scribe to write faster by smoothing the articulation of each letter, then linking letters and, at times, entire words, *shikasteh* became the favoured script for official documents and administrative correspondence. Each page in this album is a demonstration of the virtuosity of the calligrapher, showing different compositions and hands. The album is in the form of an accordion (also known as a concertina-type album) that was popular under the Qajars, who ruled a united Iran between 1794 and 1925. Each calligraphic specimen is set within plain-coloured borders on an undecorated coloured background. The folios were then hinge-linked, creating an accordion effect.

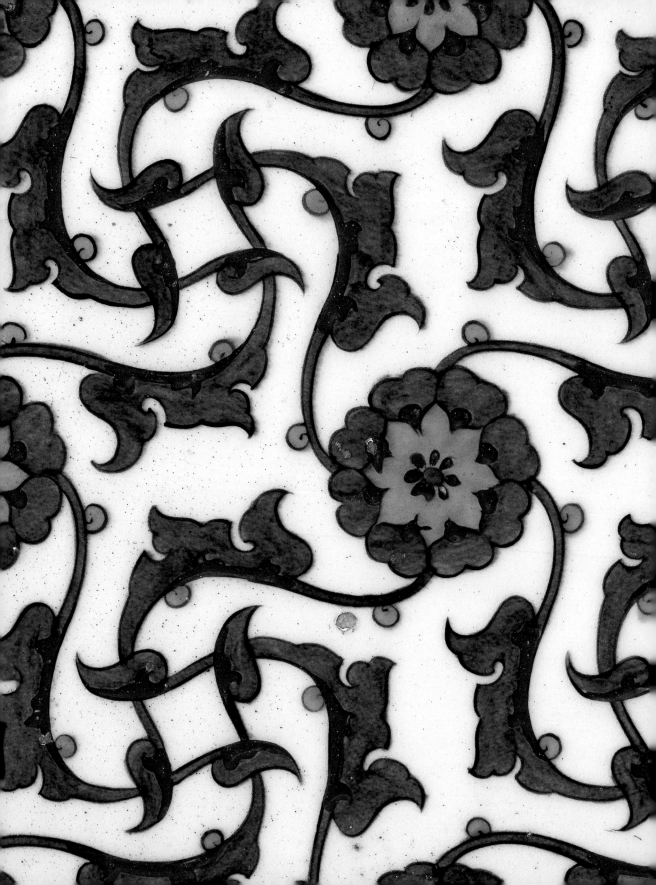

Architectural Decoration

Muslim civilizations inherited the use of architectural elements decorated with intricate designs of geometric, calligraphic, figural, and floral motifs from the diverse cultures that preceded them. By the eleventh century, the creative combinations of abstract floral patterns (also known as arabesque), geometric interlace (*girih*), and stalactite vaults (*muqarnas*) established a new aesthetic that was both dynamic and distinctive of Islamic civilizations. While the application of these elements was widespread, the technique of decoration and its location on a building reflected the various regional styles and local building traditions of the places where they were built.

Common among the decorative elements in the following examples from the Aga Khan Museum's collection are patterns based on a seemingly infinite repetition of designs and motifs. Division and repetition of abstract forms of vegetation, for example, are extended indefinitely and used in tiles to decorate the interior (AKM584) and exterior (AKM572) of a building. Geometric interlace patterns (*girih*) also follow the same structural principle; these decorative compositions are based on the folding and repetition of circles, triangles, and squares (AKM730). The resulting patterns are mathematical in nature, and their aesthetic value lies in the artist's choices regarding what aspect of the pattern to highlight, what material and technique to use, and which colours to apply.

Calligraphy played an important role in architectural decoration. Whether the content of an inscription is historical, giving the date of a building; a foundation inscription commemorating a patron and listing his or her titles; literary quotations (AKM631); or verses from the Qur'an (AKM628), these inscriptions were placed inside or outside the building where they were clearly seen and appreciated. Inscriptions are found above doors, entrances, windows, and niches; as friezes adorning the upper parts of walls; covering the interior and exterior of domes; and as overall exterior decoration.

Detail from **Tile**
(see page 150)
Iznik, Turkey,
ca. 1560
Fritware,
underglaze-
painted
25 × 24.5 cm
AKM583

This beam is a rare example of decorative carved wood surviving from Egypt before the Fatimids (909–1171). Although we do not know its original function, the beam was initially part of a longer frieze of Qur'anic inscriptions (here containing verses Q67:13–14). The Arabic letters are carved in a heavy, angular Kufic script with decorative pointed finials. The fashion for similar wooden beams with carved Qur'anic inscriptions can still be seen in the Mosque of Ibn Tulun built during the Tulunid dynasty (868–905) that governed Egypt under the Abbasids (750–1258). The austere exterior of the mosque is contrasted by the architectural decoration of its interior, which features carved plaster (stucco) and wooden beams with elaborate decorative patterns and inscriptions.

Beam
Egypt, 9th century
Carved wood
Length 120 cm
AKM701

Funerary Stele

Egypt or North Africa, 987

Carved marble

Height 59.7 cm

AKM662

Marble *spolia* from the remains of Pre-Islamic Classical buildings were widely reused throughout history, especially in places where marble was rare or quarries were no longer productive. Here, a Roman panel with a deeply carved acanthus scroll formed the back of a funerary stele dating to December 986. This cultural adaptation of architectural elements was common under Muslims in North Africa. Indeed, the Mosque of 'Amr, first established in Fustat (present-day Cairo) in 642, has a plethora of repurposed marble columns.

A rare survival from the Umayyad period in Spain (756–1031), this architectural fragment would have been part of the decorative frieze of the interior of a mosque. The inscription bears the Qur'anic verse of light (Surat al-Nur), which is an allegorical reference to Divine Light. The verse was commonly used to adorn mosques, especially their vase-shaped lamps. The inscription is carved in deep relief in a foliated Kufic script surmounted by a repetitive floral element.

Beam with Surat al-Nur
Spain (Historic al-Andalus),
10th–11th centuries
Carved wood
427 × 16.7 cm
AKM628

Cenotaph

Egypt or Tunisia, 1011
Carved marble
160 × 22 × 17 cm
AKM912

This type of cenotaph with its fine carving and elaborate inscription would have been part of the tomb of a notable individual. The inscription carries the name of an anonymous female, "al-Qamar, daughter of al-A'la," who died in September 1011. Qur'anic verses and the Muslim profession of faith (*shahada*) cover the remaining sides of the upper section of the cenotaph. The inscriptions are carved in a foliated Kufic script with curling leaves decorating the uprights of all the letters. The form of the cenotaph, the calligraphic style, and the half-palmette element that decorates the end panels are typical of carved marble cenotaphs from North Africa dating to the Fatimid period (909–1171). This one, however, is the earliest known.

One of a pair of beams belonging to a carved frieze, this object would have been part of the interior walls of the residence of a learned patron. The angular Kufic script carved in relief on an elegant leafy scroll background is part of a Pre-Islamic Arabic poem that extols valour in the face of danger and boasts of courage in battle. The combination of the nostalgia symbolized by the use of classical Arabic poetry and the focus on courage and warfare are characteristic of the Almohads, a Berber dynasty from North Africa that ruled Morocco and parts of Spain between 1150 and 1269. The Almohads were avid builders of city walls, madrasas, and mosques, including the Great Mosque of Seville and its famous minaret La Giralda. Such structures would have also been decorated with similar wood friezes. Surviving examples in other museum collections demonstrate that the same design and script were also used for Qur'anic inscriptions.

Beam

Morocco or Spain (Historic al-Andalus),
12th–13th centuries
Carved and painted wood
313 × 30.8 cm
AKM631

Ceiling Panel

Spain, 15th–16th centuries
Carved and painted wood
Base 170 cm, sides 171.8 cm
AKM730

This triangular panel is part of a carved wood ceiling that embellished a zone of transition linking the walls of a room to its ceiling. Considering the elaborate design and the overall effect, the room would have been quite spectacular. Interlacing star patterns in various materials and techniques were a hallmark of the arts produced in Spain under the Nasrids (1232–1492). The eight-pointed star at the centre of this triangular panel and the wooden strapwork it generates can also be seen in the architectural decoration of the Nasrid fort palace of the Alhambra in Granada as well as in the sumptuous silk textiles typical of the period.

Typical of the decorative approach to stone, this triple-arched wall panel uses the natural variety of stone colours to produce intricate polychrome compositions. Different stones and marble were cut according to the desired design, here forming a star-and-hexagon mosaic with knot-like interlace on the end spandrels. The stone mosaic was then fixed together with a layer of plaster applied to its back, turning it into a single panel easily fitted onto a wall or used as an arcade. This panel would have decorated a reception room in a residential building in Egypt or Syria of the Mamluk period (1250–1517) where arched panels, similar to this one, separated the central hall with its gushing fountain from the two raised reception areas that flanked it.

Panel

Egypt, 15th century
Marble and stone mosaic
225 × 49 × 5 cm
AKM571

Panel

Egypt, second half of 15th century
Ivory, wood, and metal in a
wooden frame
Diameter 22 cm
AKM703

Geometric compositions based on stars and polygons were a common feature of the decorative language of Egypt and Syria under the Mamluks (1250–1517). This sixteen-point star-shaped panel inlaid with finely carved ivory was probably a central piece in a repetitive pattern that adorned the interior of an important building. The inscription in the centre of the panel is the heraldic blazon of the Mamluk Sultan al-Ashraf Qaytbay who ruled between 1468 and 1496. The star-shaped panel was probably meant for one of his architectural projects and bears resemblance to the superb star patterns decorating the wooden pulpit (*minbar*) of Qaytbay's complex, which was built in Cairo's north cemetery in the 1470s. Geometric patterns and heraldic blazons were employed extensively by the Mamluks on a broad variety of objects and in different media.

This arch-shaped tile is an example of the opulence of Timurid (1370–1507) architectural decoration in Central Asia that can be seen in Timur's (or Tamerlane's) mausoleum (circa 1400–04) or the royal necropolis of Shah-e Zendeh in Samarqand in present-day Uzbekistan. Here, the artist demonstrates an immense skill by combining two techniques of carving and rendering them in the typical palette of Timurid architectural decoration: turquoise, blue, and white. The turquoise frame has an abstract vegetal motif of a continuously unfolding vine that was deeply hand-carved into the surface of the tile. This frame surrounds a perfectly balanced geometric interlace with a star pattern incised in its central field. The carving was done while the tile was still soft, with the glazing applied in the form of powdered minerals fused into shiny glazes of different colours when baked in the kiln.

Tile Panel

Central Asia, 14th century
Earthenware, carved and glazed
56 × 39 cm
AKM572

Tile Panel

Central Asia, second half of 14th century

Earthenware, carved and glazed

51.8 × 37.5 × 6.4 cm

AKM827

Part of a larger decorative composition, this single tile would have covered the exterior of a building in the second half of the fourteenth century, most probably in present-day Uzbekistan. The shape of the tile indicates that the overall design may have been developed on paper and later transferred to individual tiles. The design consists of two deeply carved elements separated by a flat, incised frame covered in white glaze. The section on the right has an inscription in Arabic stating that "sovereignty belongs to God" where the uprights of the letters are interlaced and knotted to create a complex pattern. The left panel comprises repetitive vertical cartouches of a typical Timurid split-palmette motif alternating with a six-point star. The whole design is carved in relief and glazed in a copper compound fluxed in an alkaline coating to produce the turquoise colour typical in the architectural embellishment of Central Asia.

By the sixteenth century, mosques and palaces built under the Ottomans (1299–1923)
had predominantly plain ashlar exteriors with a profusion of colours and patterns on the
interior in the form of glazed tiles, carpets and textiles, painted ceilings, and monumen-
tal inscriptions. These tiles are part of a repeat-pattern composition, an example of which
adorns the walls of the sixteenth-century Rüstem Pasha Mosque in Istanbul. Typical of tiles
with repeat patterns, the underglaze-painted design would have been applied to the tile
through the use of a stencil. The design itself is highly complex. It is an exquisite example
of a floral spray around a central motif demonstrating the folding, rotation, and repetition
of patterns that characterize Islamic art. The colours are also representative of the Ottoman
taste with combinations of turquoise, cobalt blue, white, and red.

Tiles

Iznik, Turkey, ca. 1560
Fritware, underglaze-painted
Each 25 × 24.5 cm
AKM583 and AKM584

Tile Frieze

Iznik, Turkey, ca. 1570

Fritware, underglaze-painted

15.5 × 75 × 1 cm

AKM698

This tile frieze is inscribed with verse 64 of the twelfth sura of the Qur'an: "Allah is the best guardian, and He is the most merciful of the merciful." It would have formed an integral part of a decorative program in an Ottoman mosque in the second half of the sixteenth century. Cartouches with Qur'anic verses painted under a clear glaze and calligraphic panels with the names of the Prophet, the first four caliphs, and the Prophet's two grandsons, Hassan and Husayn, as well as painted floral motifs, were the predominant decorative elements in Ottoman mosque interiors. The distinctive tomato-red colour used to frame the calligraphic cartouche here indicates a date later than the 1550s when this red was first employed in Ottoman tile production at Iznik in present-day Turkey.

Using bright colours under a clear glaze, this single tile depicts a topographical representation of the Ka'ba and the Masjid al-Haram in Mecca. The Ka'ba, distinguished by its rectangular form and the black cloth with a gold trim cover (known as *kiswa*), is believed by Muslims to be the place that the patriarch Abraham built to worship God. This is reflected in the main inscription beneath the arch that contains a verse from the Qur'an reminding believers of Abraham's faith and the importance of pilgrimage (*hajj*) to Mecca (Sura 3:96–97). Tiles of this type were common under the Ottomans (1299–1923) and were used to decorate the *qibla* wall of mosques and religious buildings, indicating the direction of prayer and commemorating pilgrimage.

Tile

Iznik, Turkey, 17th century
Fritware, underglaze-painted
52 × 32 cm
AKM587

Tile Panel

Iran or India (Historic Hindustan),
17th century
Earthenware, *cuerda seca* and glazed
47.8 × 24 cm
AKM590

These two tiles are exquisite examples of the natural illustration of flowers and plants in architectural decoration common in India and Iran in the seventeenth century. Here, the clump of irises with long, flowering stems and sword-shaped leaves would have been part of a larger composition surrounding an arched opening. Artists used a tilework technique known as *cuerda seca* (dry cord) to create complex designs with clearly defined components. The black outline of the design consists of a waxy material that acts as a resistant or separator to the different-coloured compartments of the design. The colours are then applied in the form of various powder minerals that fuse in the kiln into the desired colours. This technique allowed the artist to present a close depiction of his subject, which in some cases included a variety of birds and animals.

Contributors' Biographies

Philip Jodidio has written or edited more than a hundred books on architecture and art, including *Discovering Architecture: How the World's Great Buildings Were Designed and Built* (2013), *Under the Eaves of Architecture: The Aga Khan: Builder and Patron* (2007), and the *Architecture Now!* series of books (2001–ongoing). For more than twenty years he was Editor-in-Chief of *Connaissance des Arts* in Paris.

Ruba Kana'an is the Head of Education and Scholarly Programs at the Aga Khan Museum in Toronto, Canada. She is a specialist on the urban histories of Pre-Modern Muslim societies as well as on the interface between art and law in Muslim contexts. Dr. Kana'an has taught extensively at the graduate and undergraduate levels on various aspects of Islamic art and Islamic studies and developed Oxford University's first online course on Islamic art.

Henry S. Kim is the Director and CEO of the Aga Khan Museum in Toronto. An ancient history scholar and classical archaeologist by training, Kim joined the Aga Khan Museum from the University of Oxford where he taught, curated collections, and managed capital projects at the Ashmolean Museum from 1994 to 2012. Educated at Harvard and Oxford, he served as Curator of Greek coins and university lecturer in Greek numismatics at the university. From 2004 to 2011 he was the Project Director for the Ashmolean Redevelopment Project, a redevelopment and transformation of the museum.

Assadullah Souren Melikian-Chirvani is the Curatorial Director of the Aga Khan Trust for Culture and is an internationally renowned cultural historian of the Iranian world and its sphere of influence, including the Persian-speaking courts of Islamic India. A Research Director at the National Centre of Scientific Research in Paris, which he joined in 1970, he retired in 2004. Throughout his career he focused on the connection between the written word and the visual arts. His groundbreaking discoveries include the demonstration of the Buddhist background to the depiction

of ideal beauty, the "Moon-Faced Buddha," in literature and art; the role of the *Shah-Nameh* as a behavioural model in the *Shah-Nameh* visual and auditory environment of Iranian courts; and the universal correlation between motif and literary concepts in Iranian culture. He is the author of numerous scholarly articles and five pioneering books, among them *Islamic Metalwork from the Iranian World, 8th to 18th Centuries* and *Le chant du monde: L'art de l'Iran safavide.* From 1969 to 2013 he wrote a weekly column in the *International Herald Tribune* under the name "Souren Melikian" and retired as the Art Editor for that newspaper in October 2013.

Luis Monreal is the General Manager of the Aga Khan Trust for Culture in Geneva, Switzerland. He is a conservation specialist, art historian, and archaeologist, and has held various positions, including Secretary-General of the International Council of Museums at UNESCO, Paris, France (1974–85); Director of the Getty Conservation Institute, Los Angeles (1985–90); and Director General, La Caixa Foundation, Barcelona, Spain (1990–2001). Monreal is the author of several books that have been published in many languages and has also been involved in the creation and establishment of a number of museums.

D. Fairchild Ruggles is Professor of Landscape History at the University of Illinois at Urbana-Champaign and is the author of *Islamic Art and Visual Culture* (2011), *Islamic Gardens and Landscapes* (2008), and *Gardens, Landscape, and Vision in the Palaces of Islamic Spain* (2000).

Illustration Credits

Copyright © Aga Khan Museum, 2014 (photos by Gérald Friedli): pages 1, 4, 16, 42, 50–51, 53–57, 62, 78 (left), 79–84, 87, 96, 102–05, 119, 124, 140–41, 142–43 (top), 144, 146.

Tom Arban Photography: endpapers, pages 2, 20–21, 22 (top), 24, 27 (left), 28.

Copyright © Aga Khan Development Network, 2014: pages 6 (photo by Moez Visram), 22 (bottom) and 23 (photos by Gary Otte), 32–33, 37, 38 (right).

Copyright © Aga Khan Museum, 2014 (photos by Sean Weaver): front cover, pages 10–11, 13–15, 17–19, 40–41, 45–49, 52, 58, 60–61, 63–72, 74–77, 78 (far right), 86, 88–95, 99–101, 106–14, 116–18, 120–23, 125–26, 128–38, 143 (bottom), 145–53, back cover.

Copyright © Imara (Wynford Drive) Limited, 2014: pages 25, 30–31, 35, 36 (top).

Copyright © Studio Adrien Gardère, 2014: page 26.

Copyright © Maki and Associates, 2014: page 27 (right).

Copyright © Vladimir Djurovic Landscape Architecture, 2014: page 36 (bottom).

Copyright © iStock, 2014: page 38 (left).

Index

Page numbers in italics indicate illustrations.

First published in Canada in 2014 by
Aga Khan Museum
77 Wynford Drive
Toronto, Ontario
M3C 1K1
www.agakhanmuseum.org

For Aga Khan Museum:
Feasibility Studies: Sasaki Associates, Boston, Massachusetts, United States
Design Architects: Fumihiko Maki and Maki and Associates, Tokyo, Japan
Architect of Record: Moriyama & Teshima Architects, Toronto, Ontario, Canada
Landscape Architects: Vladimir Djurovic Landscape Architecture (VDLA), Beirut, Lebanon
Museography and Exhibition Design: Studio Adrien Gardère, Paris, France

Education and Scholarly Programs Department, Aga Khan Museum:
Ruba Kana'an, Head of Education and Scholarly Programs
Michael Carroll, Editor and Publications Manager

Design: Steven Schoenfelder

5 4 3 2 1 18 17 16 15 14

Library and Archives Canada Cataloguing in Publication

Kim, Henry S., author
Aga Khan Museum guide / Henry S. Kim, Ruba Kana'an, Philip Jodidio, D. Fairchild Ruggles.

Includes index.

Issued also in French under title: Guide du Musée Aga Khan.
ISBN 978-09919928-6-7 (pbk.)

1. Aga Khan Museum (Toronto, Ont.)--Guidebooks.
I. Ruggles, D. Fairchild, author II. Jodidio, Philip, author
III. Kana'an, Ruba, author IV. Aga Khan Museum (Toronto, Ont.), issuing body V. Title.

N6264.C3T668 2014 709.17'67074713541
C2014-905830-6

On front cover: Planispheric Astrolabe, Spain (Historic al-Andalus), 14th century, bronze inlaid with silver, diameter 13.5 cm, AKM611 (see also pages 13–15 and 78).

On endpapers: Detail of *mashrabiya* pattern of the glass courtyard wall in the Aga Khan Museum.

On page 1: Bottle, Iran, 12th century, glass, height 23 cm, AKM661.

On page 2: Detail of one of the courtyard glass walls with *mashrabiya* pattern in the Aga Khan Museum.

On page 4: *Episode from the Story of Haftvad and the Worm*, folio 521v from a *Shah-Nameh* (Book of Kings) produced for Shah Tahmasp I, signed by Dust Mohammad, Tabriz, Iran, ca. 1540, opaque watercolour, ink, gold, and silver on paper, 45 × 30 cm, AKM164.

On pages 40–41: Beggar's Bowl (*Kashkul*), Iran, late 16th century, engraved brass, length 61 cm, AKM612 (see also page 92).

On back cover: Detail of *Genealogical Chart of Jahangir*, signed by Dhanraj and anonymous artists, Agra, India (Historic Hindustan), 1610–23, opaque watercolour, ink, and gold on paper, 36.2 × 24.2 cm, AKM151 (see also page 110).

Printed in Canada